AMERICAN PRESIDENTIAL CHINA

The Robert L. McNeil, Jr., Collection at the
Philadelphia Museum of Art

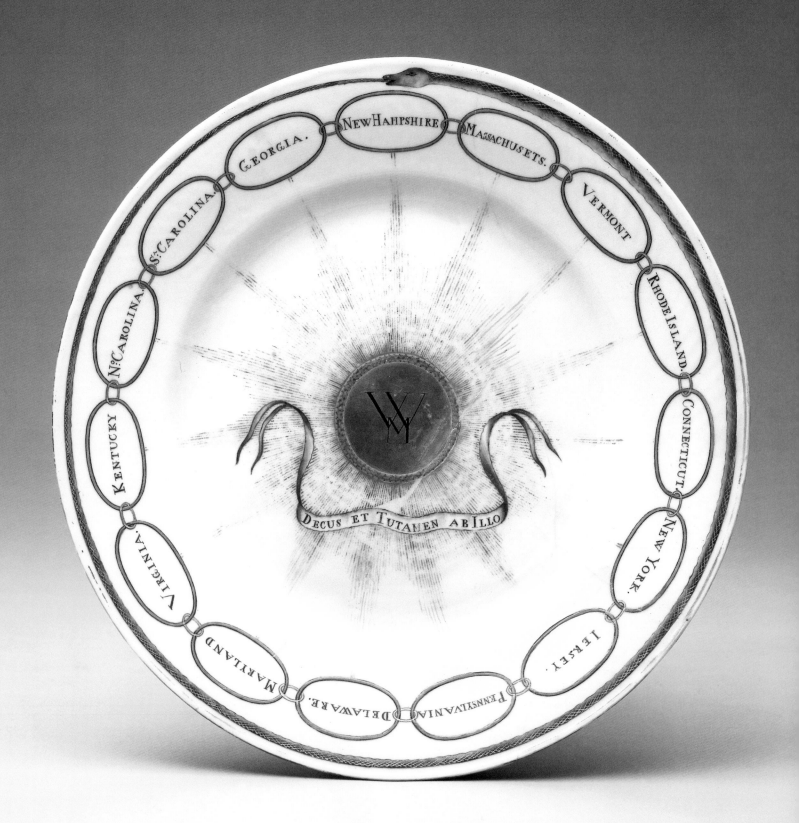

AMERICAN PRESIDENTIAL CHINA

The Robert L. McNeil, Jr., Collection at the Philadelphia Museum of Art

Susan Gray Detweiler

with an introduction by David L. Barquist

PHILADELPHIA MUSEUM OF ART

This catalogue is supported by an endowment for the
Center for American Art at the Philadelphia Museum of Art.

PHOTOGRAPHY CREDITS

Will Brown: Frontispiece; cats. 1, 3, 6, 13, 18, 21–24, 29–32, 37, 42, 45–47, 49, 54, 58, 60–63, 67, 68, 80, 84, 87, 90, 97, 106, 109, 115, 125, 133, 156, 159, 162, 166–68, 174, 178, 179, 183–86, 188, 191, 199

Andrea Simon: Figs. 10, 11; cats. 66, 69, 116, 147, 192

Graydon Wood: Cover; pages 6, 8, 22; cats. 2, 12, 17, 19, 20, 34, 35, 38, 39, 50–52, 75, 76, 93, 94, 104, 119, 121, 123, 126, 128, 130, 131, 134, 136, 140, 146, 154, 165, 201

Front cover: Six pieces from the Lincoln State Dinner and Dessert Service, 1861 (cats. 73–77) and 1873 (cat. 84)

Back cover: *Dinner Service Platter* ("Wild Turkey") from the Hayes State Dinner and Dessert Service, c. 1882 (cat. 131)

Page 2: *Plate* from the Washington Cabinet Service, 1796 (cat. 13)

Page 6: *Fruit Stand*, *Two Compotes*, and *Dessert Plate* from the Polk State Dinner and Dessert Service, 1846 (cats. 60–62, 65)

Page 8: Detail of *Oyster Plate* from the Hayes State Dinner and Dessert Service, c. 1880–87 (cat. 126)

Page 22: Detail of *Game Plate* from the Hayes State Dinner and Dessert Service, c. 1880–87 (cat. 134)

Produced by the Publishing Department
Philadelphia Museum of Art
Sherry Babbitt, Director of Publishing
2525 Pennsylvania Avenue
Philadelphia, PA 19130
USA
www.philamuseum.org

Edited by David Updike
Production by Richard Bonk
Designed by Dean Bornstein
Manufactured in China by Oceanic Graphic Printing

Text and compilation © 2008 Philadelphia Museum of Art

LIBRARY OF CONGRESS CATALOGING-IN-PUBLICATION DATA

Detweiler, Susan Gray.
 American presidential china : the Robert L. McNeil, Jr., collection at the Philadelphia Museum of Art / Susan Gray Detweiler ; with an introduction by David L. Barquist. — 1st ed.
 p. cm.
 Includes bibliographical references.
 ISBN 978-0-87633-192-7 (PMA hardcover)
 ISBN 978-0-300-13593-0 (Yale hardcover)
 1. Porcelain—Private collections—Exhibitions. 2. Presidents—United States—Collectibles—Exhibitions. 3. McNeil, Robert L., Jr.—Art collections—Exhibitions. I. Title.
 NK4370.D48 2007
 738.2074'74811—dc22

 2007019543

NOTES TO THE READER

All objects in the catalogue are gifts of Robert L. McNeil, Jr., to the Philadelphia Museum of Art, and are identified by their Museum accession numbers. The provenance information is taken primarily from Mr. McNeil's extensive records on the collection. Life dates are given for historical personages, and their city of residence given when known. References to the sale and lot number are given for objects that were acquired at auction.

All decoration is overglaze and all marks and labels are located on the underside of the object unless otherwise noted. Many of these pieces have slightly irregular shapes; in each case, the dimensions given represent the maximum measurement.

Objects that are illustrated in the catalogue are indicated by an asterisk.

CONTENTS

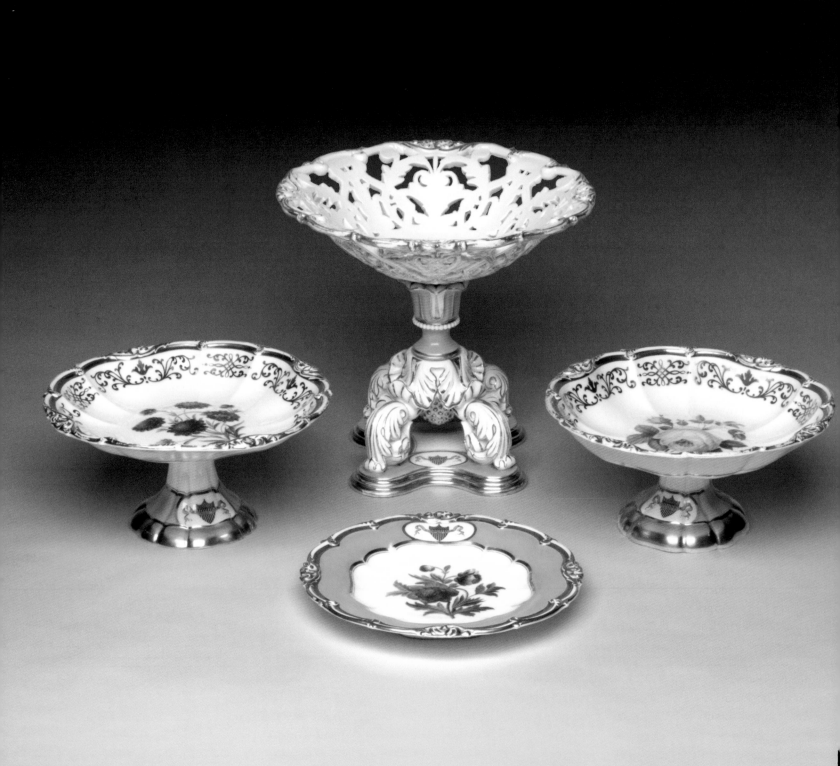

FOREWORD

The Philadelphia Museum of Art's holdings in American ceramics have long been one of its greatest strengths. Edwin AtLee Barber (1851–1916), the pioneering curator and later director of the Museum, assembled a still-unsurpassed group of early Pennsylvania German earthenwares. The Museum's definitive collection of wares made by William Ellis Tucker and his partners in Philadelphia between 1826 and 1838 is enriched by the manuscript materials donated by Tucker's descendants in 1951. The ceramics collection was further strengthened in 1999 and 2002, when Virginia and the late Gerald Gordon gave 150 works by Rookwood Pottery of Cincinnati, in celebration of the Museum's 125th anniversary.

In the most recent of his many acts of spectacular generosity, Robert L. McNeil, Jr., in 2006 presented the Museum with his outstanding collection of American presidential china. These choice holdings, assembled over a period of almost fifty years, from the purchase of a George Washington plate in 1960 (cat. 6) to the addition in 2007 of the spectacular bonbon and tambour stands from Andrew Jackson's 1833 dessert service (cats. 50, 51, 53), form the most comprehensive collection heretofore in private hands, covering presidents from George Washington to Ronald Reagan.

A prime force behind this remarkable collection has been Susan Gray Detweiler, who has served as Mr. McNeil's curator of ceramics since 1969. Her careful and insightful research has resulted in this splendid catalogue as well as her outstanding 1982 publication, *George Washington's Chinaware*. She also organized two exhibitions from the collection, one for the Smithsonian Institution Traveling Exhibition Service in 1975 and the other for the Philadelphia Museum of Art in 1982.

David L. Barquist, Curator of American Decorative Arts, has contributed an introduction to the catalogue placing the objects in a larger context. We are also grateful to David and his colleagues in the American Art Department, Nancy M. McNeil Associate Curator Elisabeth Agro, Assistant Curator Alexandra Alevizatos Kirtley, and Research Assistant Jennifer Zwilling, for their assistance in recording and verifying information in the entries. From the first conversations concerning the McNeil Collection, Donna Corbin, Associate Curator of European Decorative Arts after 1700, has offered many valuable insights and a wealth of infor-

mation to her fellow curators in American Art. Betty C. Monkman and William G. Allman, prior and current curators at the White House, and the late Margaret B. Klapthor (1922–1994), former curator in the Division of Political History at the Smithsonian Institution, have generously shared their discoveries with colleagues. We are also very grateful to Letitia Roberts, a longtime friend of the Museum, for her observations and research as she appraised the collection. Jean Harlow kindly brought the wonderful photograph of Girl Scouts selling presidential china to our attention. Ulysses Grant Dietz and Claire Telecki were very helpful in clarifying the provenance of Grant family objects.

Many colleagues at the Museum and elsewhere have contributed to this catalogue. Under the masterful guidance of Sherry Babbitt, Director of Publishing, the book has been produced by Richard Bonk and edited by David Updike. Dean Bornstein created the elegant design that complements these tablewares. Will Brown took the majority of the photographs for the Barra Foundation, which graciously permitted their use here, with additional photography by Graydon Wood and Andrea Simon. We are also grateful to Amanda Jaffe in the Rights and Reproductions Department for coordinating photography at the Museum. Alice Beamesderfer, Associate Director for Collections and Project Support, Rachel Ciba Markowitz and Carol Ha in the American Art Department, and Clarisse Carnell and Nancy Baxter in the Registrar's Office have handled myriad administrative details, both for this publication and in making the McNeil Collection part of the Museum.

The McNeil Collection at one stroke provides our visitors with a fascinating survey of ceramic tablewares used in the United States from its founding to the end of the twentieth century. Through the generosity of Mr. McNeil, these important pieces of our nation's cultural legacy will now be enjoyed by the public for generations to come.

ANNE D'HARNONCOURT
The George D. Widener Director and Chief Executive Officer

KATHLEEN A. FOSTER
The Robert L. McNeil, Jr., Curator of American Art

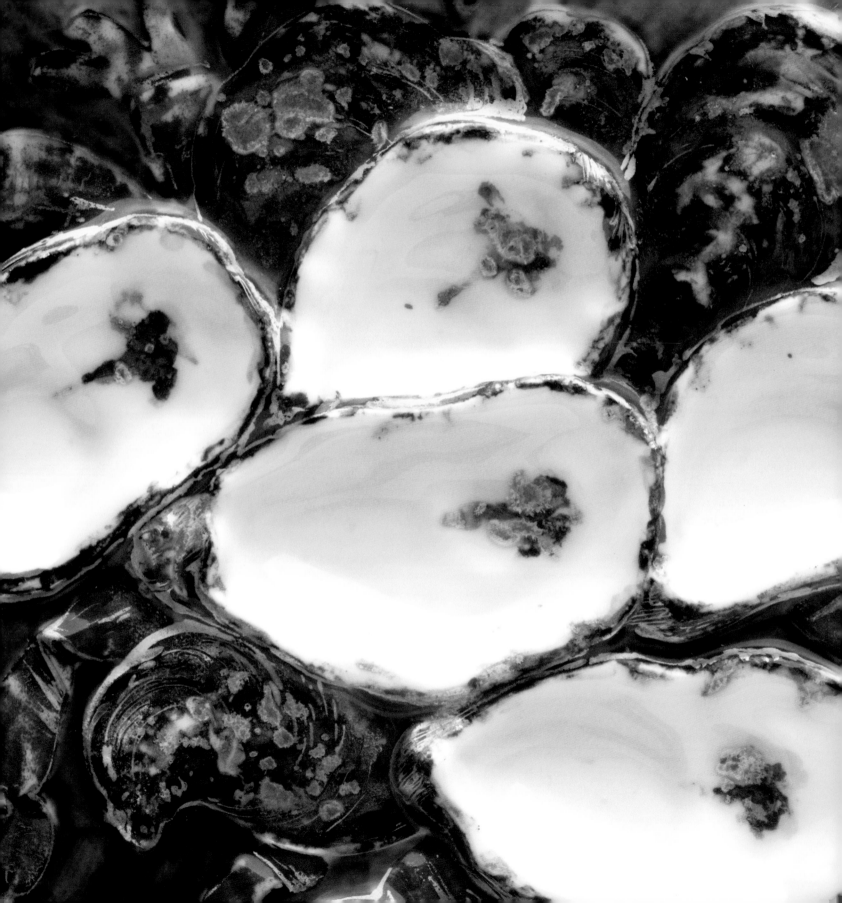

PRESIDENTS AND PORCELAIN
"To Fix the Taste of Our Country Properly"

DAVID L. BARQUIST

In the United States, as elsewhere, the conduct of government, politics, and diplomacy has often required people to gather for meals, and from the beginning American presidents and their families have acquired distinctive ceramics for entertaining. The Robert L. McNeil, Jr., American Presidential China Collection at the Philadelphia Museum of Art provides a unique overview of changing styles and forms of ceramics used in an elite and highly visible American household since the late eighteenth century. It documents changes in preferences for porcelain from different countries and factories as well as the rise of an American ceramics industry. It also illustrates the relationship between the tastes of various presidents and those of the nation as a whole—with some administrations in the vanguard and others reflecting more conservative dining styles and practices.

Although the first four presidents used both new and second-hand tableware at their official residences, little is known to have survived—due in no small part to the burning of the White House by the British in 1814. Exceptions include the French porcelain personally acquired by George Washington and James Madison for formal entertaining (cats. 23–30, 34, 35). Beginning in 1817, the U.S. government has commissioned seventeen state services—that is, tableware purchased for formal use at the White House—all but two of which are represented in the McNeil Collection.[1] Emblazoned with the arms of the United States, the presidential seal, or images of the White House, these state services represented the greatness of the country and the dignity of its leader to visitors to the Executive Mansion (fig. 1). Some of these services enjoyed long popularity, with multiple reorders. The Lincoln state service of 1861 remained popular in the later nineteenth century (cats. 84–86) and continued in use at the White House into the twentieth. In 1993, Bill and Hillary Clinton ordered supplements to the Wilson and Franklin Roosevelt state services;[2] in 2000, however, the Clintons commissioned the "Millennium" state service, which George W. and Laura Bush used in 2007 to entertain Queen Elizabeth II (fig. 2).

With a few exceptions, ceramic tableware acquired by presidents was made of porcelain. Strong yet thin and translucent, with a clear, white body that set off rich enamel colors and gilding, porcelain was the most desired ceramic in the West when the United States became

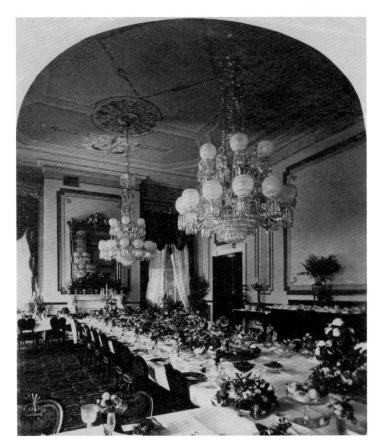

FIG. 1. The State Dining Room at the White House, January 6, 1881, the tables set with dinner plates from the Hayes state service. (Courtesy of the Rutherford B. Hayes Presidential Center, Fremont, Ohio)

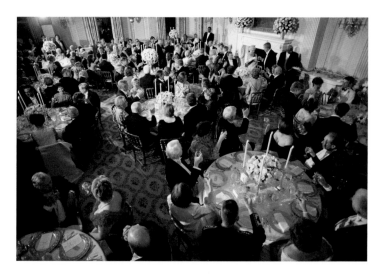

FIG. 2. State dinner given by George W. Bush for Queen Elizabeth II of Great Britain in the State Dining Room of the White House, May 7, 2007, with the tables set with service plates from the Clinton "Millennium" state service. (White House photograph by Eric Draper)

an independent nation. From the sixteenth century onward, Europeans had attempted to duplicate hard-paste Chinese porcelain, and by the third quarter of the eighteenth century factories producing hard- and soft-paste porcelain were operating in Germany, Austria, Italy, France, and Britain. All nine of the nineteenth-century state services were made by leading French porcelain factories, a preference that can be explained both by that country's long political alliance with the United States and its reputation as the epicenter of style. The firms chosen for these commissions were not premier manufacturers such as Sèvres but ones that tended to have significant connections to the American market. Edouard Honoré (d. 1855), a partner in the Parisian firm that made the 1817 Monroe state service and subsequent founder of the eponymous firm that produced the 1846 Polk state service, had a large export business to the United States.[3] Haviland and Company, which made the 1870 Grant and the Hayes state services, was founded in Limoges in 1841 by a family of New York china merchants to produce wares suited to American tastes. By the 1870s the company was shipping four hundred barrels of china monthly to the United States and exhibiting at international fairs, including the Centennial Exhibition in Philadelphia.[4] Tressemanes and Vogt, also of Limoges, another partnership between a New York china merchant and a French agent, similarly manufactured wares for a large export business to the United States and supplied the Harrison state

service.[5] American firms that retailed other services likewise had close French connections. Eder V. Haughwout of New York, who supplied and decorated the Pierce and 1861 Lincoln state services, imported from France not only the porcelain blanks but also such items as "glassware, mirrors, bronzes, silver platedware, gasfixtures, cutlery, and parian statuary," maintaining a branch office in Paris between 1857 and 1869.[6]

Although the domestic porcelain industry matured in the second half of the nineteenth century, it was not until 1918 that an American firm was deemed capable of producing a state service.[7] William McKinley had ordered a set of plates in 1898 from his friend and political supporter Colonel John N. Taylor, partner in the East Liverpool, Ohio, ceramics company of Knowles, Taylor and Knowles (cats. 154, 155), but these were criticized for their inferior quality. Four years later, Knowles, Taylor and Knowles was approached about producing a 1,300-piece state service for Theodore Roosevelt, but the company declined because the scale of its operations was insufficient to take on so large an order without "much interruption of regular business," and the commission went to Wedgwood, the only English firm to supply a state service.[8] The other seven state services ordered during the twentieth century were made by American companies: the Wilson, Franklin Roosevelt, Truman, Reagan, and Clinton services were commissioned from Lenox Incorporated in Trenton, New Jersey, and the Eisenhower service plates and Lyndon Johnson service were ordered from Castleton China, a division of Shenango Potteries in New Castle, Pennsylvania.

Each state service is identified with the president for whose administration it was purchased, but the process of commissioning and ordering these tablewares involved many intermediaries. During the nineteenth century, the commissioner of public buildings was responsible for such purchases, which came from a congressional appropriation for White House furnishings made at the beginning of each administration. In some cases, the commissioner represented his presidential client in negotiations, as Colonel Thomas Casey did for the Hayes service of 1879. In others, the retail firms supplying the White House played a key role. The Philadelphia china and glass retailer Lewis Veron supplied Andrew Jackson's state service in 1833. By the late 1860s, china and glass retailers in Washington, D.C., were handling orders for new state services as well as supplying other presidential ceramics: these included J. W. Boteler and Brother (cats. 84, 85, 94–102, 104, 105), M. W. Beveridge (cats. 145–50, 152), and Dulin and Martin Company (cats. 16, 151, 156–58, 165). In 1902, as Edith Carow Roosevelt was considering a new state service, Charles Manning Van Heusen of the Van Heusen Charles Company in

Albany, New York, assembled seventy-eight samples from European and American porcelain companies for her review. The Truman state service was ordered through B. Altman and Company in 1951 as part of their commission to redecorate the White House.

Some First Ladies played a more active role in these commissions: Mary Lincoln purchased state services in 1861 (cats. 73–79) and 1865 (cats. 87–92), the latter from J. K. Kerr's "China Hall" in Philadelphia. At least two First Ladies, Caroline Scott Harrison (cats. 145–47) and Claudia Taylor "Lady Bird" Johnson (cats. 192–96), participated in the design of their state services. Private citizens were also influential. The banker and art collector William W. Corcoran (1798–1888) ordered the Polk state service (cats. 55–65) in 1846 through A. T. Stewart's famous "Marble Palace" department store in New York, and the artist Theodore R. Davis's chance meeting with Lucy Hayes resulted in his commission to design the 1879 state service (cats. 116–39).[9]

From the beginning, U.S. presidents faced the problem of maintaining an image appropriate for a world leader without seeming to rise too far above their fellow citizens. Over the centuries, the tableware they and their families have chosen for private or less formal occasions—as well as for use on presidential yachts (cats. 174, 183) and airplanes (cats. 184, 186, 200)—have run the gamut from Chinese export porcelain (cats. 1, 37, 107–14) to English earthenware (cats. 49, 93, 189–91). Most of these tablewares are more modest in form and ornament than the state services. Many feature simple gold or colored bands on a white ground (cats. 104, 105, 189–91); others are standard patterns customized with initials or a monogram (cats. 32, 106–12, 156–58, 167). Mary Lincoln's decision to order a personal service of the same design as her 1861 state service, substituting her initials for the arms of the United States, led to accusations that she had misappropriated public funds, probably because her choice of an official pattern had transgressed the boundary between personal and public. Margaret Klapthor has suggested that Mrs. Lincoln ordered the 1865 state service, which is much simpler than its predecessor, because the controversy gave the earlier service unpleasant associations.[10]

Three Centuries of Dining Styles and Forms

During the nation's first presidency, George and Martha Washington acquired Chinese and French porcelain that reflected the eighteenth-century love of classical imagery and allegory. Figures representing deities (cats. 19, 20) and the seasons (cats. 21, 22), the personification of Fame painted on the "Cincinnati" service (cats. 3–7), and the wreaths

FIG. 3. *Plate from a Dinner Service*, 1784. Made by the Sèvres porcelain factory, Sèvres, France; painted by Cyprien-Julien Hirel de Choisy (French, active 1770–1812). Porcelain with enamel and gilt decoration; diameter 9⅜ inches (23.8 cm). Philadelphia Museum of Art. Gift of Miss Letitia Roberts, 2002-220-1

on the Niderviller tea service (cats. 17, 18) all derive from Greek and Roman imagery. More complex allegories of national unity and prosperity were devised for Martha Washington's cabinet service (cats. 12, 13). The 1817 Monroe state dessert service celebrated the nation's victory in the War of 1812 with imagery of permanence, prosperity, and cultivation taken from Roman trophies (cats. 38–42), and Andrew Jackson's similarly neoclassical state dessert service was ornamented with eagles intended to underscore links between the Roman and American republics (cats. 50–53). However, these objects were all standard tableware forms available to affluent consumers at the time. Even the French porcelains that Washington acquired from the comte de Custine (cats. 17, 18) and the comte de Moustier (cats. 23–30) were modest when compared to those made at the same factories for European heads of state, such as the dinner service ordered from the royal porcelain factory at Sèvres by French queen Marie Antoinette in 1784, which was painted and gilded in an intricate, sumptuous pattern known as "frise riche" (fig. 3).[11]

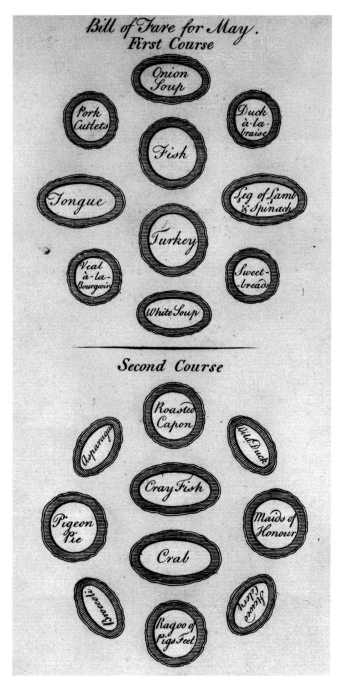

FIG. 4. *Bill of Fare for May,* suggested menu and serving arrangement for two courses of a dinner, engraving from John Farley, *The London Art of Cookery and Housekeeper's Complete Assistant* (London, 1785). (Courtesy of the Library Company of Philadelphia)

In the eighteenth and early nineteenth centuries, presidential porcelains were used primarily to serve dinner, the principal meal of the day, at about three o'clock in the afternoon. The method for setting the table, known as *service à la française*, involved placing all of the dishes for the first course on the table before the diners were seated. The food was served in tureens and on platters and other dishes laid out in crowded, symmetrical arrangements, with the larger or more spectacular dishes as "centers," surrounded by the vegetables, meat pies, and other smaller offerings (fig. 4). Table services thus required relatively few plates for individual place settings but a wide variety of forms for displaying and serving food, such as tureens (cat. 3) and sauceboats (cat. 34) in various sizes, as well as objects for preparing foods at the table, such as casseroles (cat. 23). The Jackson state dinner service of 1833, of which no examples are presently known to survive, included only flat and soup plates but had fifteen different forms for serving.[12]

Dinners usually comprised two similar courses of meat and vegetables, followed by a change of linen and tableware for the dessert course, followed in turn by nuts, fresh and preserved fruits, and wine. Like the main courses, dessert featured many dishes crowded on the table at once, and a variety of specialized forms such as chillers (cat. 28), custard or ice cream cups (cat. 29), and fruit baskets (cat. 38) were needed to present the different foods. Diners received a dessert plate and flatware for this course, which were not put on the table until the dessert was served. The Monroe state dessert service comprised flat (cats. 41, 42) and deep (cat. 40) plates for individual place settings and seven serving forms: cheese plates, footed plates, *marroniers* (chestnut dishes), sugar bowls (cat. 39), *glaciers* (ice pails), baskets (cat. 38), and compotes of *"diverses formes."*

Elite tables might also feature centerpieces or table ornaments, some of which held dessert foods, such as fruit baskets and confectionary stands (cats. 50–53), while others were purely decorative. Massachusetts Congressman Theophilus Bradbury (1739–1803) included the porcelain figures acquired in Paris for George Washington (cats. 19, 20) in his description of a dinner for twenty men in 1797 at the Executive Mansion in Philadelphia:

In the middle of the table was placed a piece of table furniture about six feet long and two feet wide, rounded at the ends ... either of wood gilded or polished metal, raised only about an inch with a silver rim around it like that 'round a tea board; in the center was a pedestal of plaster of Paris with images upon it, and on each end figures, male and female of the same. It was very elegant and for ornament only.[13]

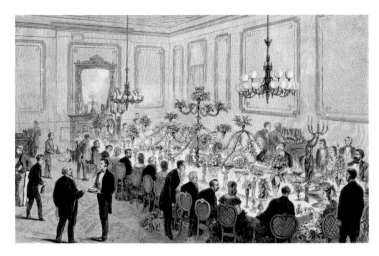

FIG. 5. State dinner given by Ulysses S. Grant for the Joint High Commissioners of the United States and Great Britain in the State Dining Room at the White House, March 1871. Colored engraving from *Frank Leslie's Illustrated Newspaper*, April 1, 1871. (Courtesy of the White House Historical Association)

An eighteenth-century host's wealth and status were measured both by the quantity of edibles and ornaments and by the variety of choices. Guests were not expected to try everything or finish the offerings. Bradbury noted that Washington's dinner included "an elegant variety of roast beef, veal, turkey, ducks, fowl, hams, etc.; puddings, jellies, oranges, apples, nuts, almonds, figs, raisins, and a variety of wines and punch."[14] Diners were expected to serve themselves from tureens and platters, helping their fellow guests to dishes in their vicinity, and anyone seated near roasted meat was expected to carve. This style of dining featured minimal intrusion of servants, who hovered in the background to clear away dishes and serve drinks from side tables.[15] Guests were not always able to reach the foods they desired; at a ball hosted in 1799 by William and Anne Willing Bingham in Philadelphia, the wife of the secretary of the navy complained, "The dessert (all was on the table) consisted of every thing that one could conceive of except jelly; though I daresay there was jelly, too, but to my mortification, I could not get any."[16]

During the second quarter of the nineteenth century, Americans began to adopt a different practice of serving meals, known as *service à la russe*—so-called because it may have originated at the Russian court. Instead of placing all the food out at once, the meal was served one dish at a time from side tables by the servants, who carved or apportioned the servings and presented them to the individual guests after everyone was seated (fig. 5).[17] The center of the table was decorated with ornaments, flowers, and candlesticks, and possibly fruit and candies. The novelist Catharine Sedgwick declared her preference in 1841 for "the most delicious atmosphere of fruit and flowers, instead of being stupefied with the fumes of meat. There was no bustle of changing dishes, no thrusting in of servant's arms."[18] The quantity and variety of dishes did not diminish, but they were distributed over many more courses. Mrs. James Dixon of Connecticut described such a dinner at the White House in 1845, using the Jackson state services:

> Sit! I guess we did sit—for four mortal hours, I judged one hundred and fifty courses, for everything was in the French style and each dish a separate course.
>
> Soup, fish, green peas, spinach, canvas back duck, turkey, birds, oyster pies, cotolettes di mouton, ham deliciously garnished, potatoes like snowballs, croquettes, poulet, in various forms, duck and olives, pate de foie gras, jellies, orange and lemon charlotte russe, ices and "pink mud" oranges, prunes, sweetmeats, mottos and everything one can imagine, all served in silver dishes with silver tureens and wine coolers and the famous gold forks, knives and spoons for dessert. The china was white and gold and blue with a crest, the eagle, of course, and the dessert plates were a mazarine blue and gold with a painting in the center of fruits and flowers.[19]

Service à la russe did not meet with universal acceptance: diarist Philip Hone of New York wrote in 1840, "I do not like the new fashion of the servants' handing round the dishes; it interrupts the conversation and I would rather see my dinner that I may be 'free to choose.'"[20] For much of the nineteenth century, cookbooks and advice manuals presented both systems, usually denoted as "English" and "Russian," with some authors proposing a compromise "American plan" in which the principal meat dishes were placed on the table while the vegetables and other accompaniments were brought in and offered by the servants.[21]

During this period, fashionable tableware moved away from classical imagery in favor of more naturalistic decorative motifs. White House state services acquired during the Polk, Pierce, Lincoln, and Grant administrations feature curvilinear shapes inspired by eighteenth-century rococo precedents. Accurately rendered images of flowers like those on Marie Antoinette's 1784 Sèvres service (see fig. 3) were revived on a much larger scale for the Polk and Grant services (cats. 61–65, 94–102), complementing the abundant floral carving and patterns used on contemporary furniture and fabrics. Much like the French porcelain owned by Washington and Monroe, however, these were routine products for

their makers. A pair of compotes by Edouard Honoré (fig. 6) now in the New Orleans Museum of Art, for example, exhibits more lavish gilded and painted ornament than similarly decorated versions of the same model furnished for the Polk service (cats. 61, 62).

By the 1860s dinner had become an evening meal.[22] The table was covered with a single cloth that remained in place. The glassware and flatware for the entire meal were laid at each place setting, and increasingly specialized forms were developed for specific foods and beverages. By the end of the century, an individual diner's place at a well-laid table in the White House or equally elite setting was literally covered with flatware and glassware (fig. 7).

Earlier dining practice had required a variety of serving vessels and only a few types of plates. In the newer system, dinner services required a wider array of plates to differentiate the changing courses, often with identical designs in multiple gradations of size, distinguished by such names as "twifflers" and "muffins."[23] The state service purchased by the Pierce administration in 1853 had fifteen forms for serving (such as "Round high Baskets," cat. 68) and nine for each place setting—dinner, soup, dessert, oyster, and tea plates (cats. 69–72) as well as cups for breakfast coffee, tea, custard, and after-dinner coffee.[24] At mid-century the preference clearly was for the traditional uniformity of presentation using large, matching dinner services. The taste for matching tableware reached its apogee in the 666-piece state service purchased by Mary Lin-

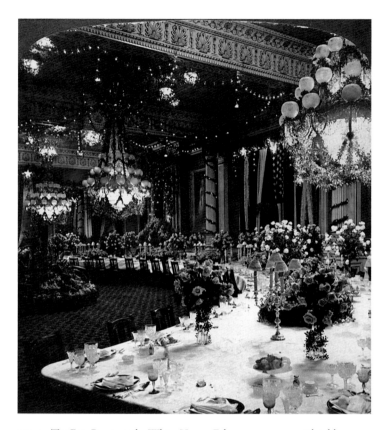

FIG. 7. The East Room at the White House, February 24, 1902, with tables set for a state dinner given by Theodore Roosevelt for Prince Henry of Prussia. (Courtesy of the White House Historical Association)

FIG. 6. *Pair of Footed Sweetmeat Stands*, c. 1845–55. Made by Edouard D. Honoré, Champroux, France (1824–55). Porcelain with enamel and gilt decoration; height 4⅝ inches (11.8 cm), diameter 9½ inches (24.1 cm). New Orleans Museum of Art. Museum Purchase: Hans H. Lorenz Memorial Fund, 1995.6.1-2

coln in 1861, with forms specifically denoted for breakfast, tea, punch, dinner, and dessert, all "richly decorated to match."[25]

By the third quarter of the nineteenth century, many authors of advice manuals rejected the monotony of serving diners on the same pattern over the course of the meal. As one author instructed: "A very simple rule for the guidance of those who wish to have their tables admired is to avoid, in successive courses, the endless repetition of the same service. . . . Have a number of sets of plates, and use a different set for each course. Then buy plates, no two of which are alike except in shape, and thus make harlequin services to vary the entertainment."[26] Another author advised a "kaleidoscopic" change of plates: "You take your soup in Sèvres, your entrées in England, or Dresden, and so on, till you come to fruit in China or Japan."[27] At the White House this taste was most evident in the 562-piece service designed by Theodore

R. Davis for Rutherford and Lucy Hayes in 1879, in which each place setting had differently shaped dishes for individual courses. Moreover, for all but the oyster and ice-cream courses these forms were decorated with one of twelve designs, using imagery of flora and fauna appropriate to that portion of the meal—crab on a soup plate (cat. 116), smelts on a fish plate (cat. 130), quail on a game plate (cat. 134), and so on—so that adjacent diners would see different decoration.

Davis believed that "work in any way pertaining to a national character should be in a measure the production of our Country,"[28] and his use of American subjects as decorative motifs had a lasting impact on White House style. Aside from simple patriotism, Davis's designs for the Hayes service can be interpreted as an elaborate statement of Manifest Destiny—the notion that it was the duty of European-descended immigrants to use their superior technology to subjugate and exploit the North American continent, including its flora, fauna, and indigenous inhabitants. By dining off of plates that represented the native plants, birds, fish, and animals that were harvested as food, American political and social leaders literally and figuratively demonstrated their dominion over the land. The need for such representations, always in the context of the American landscape, outweighed any desire for the more stylistically advanced designs seen on contemporary European wares. Although Davis's designs for the shapes (cats. 120–25, 136, 137) and compositions (cats. 128, 129) of these pieces reflected the current taste for non-Western, particularly Japanese, models, the realistic imagery of the Hayes service contrasts sharply with contemporaneous French productions, such as Félix Bracquemond's designs for the "Japanese" service of 1866–67, on which the stylized decoration, derived from Japanese prints, underscores the flatness of the plate (fig. 8).[29]

Each place setting in the Hayes service had twelve different pieces; the only serving pieces were sauceboats and platters for the fish, dinner, game, and ice-cream courses (cats. 128, 131, 133, 120), an indication of how radically dinner services had changed since the era of Monroe and Jackson.[30] This emphasis on the forms for individual place settings would be a feature of all the state services made during the twentieth century. The Theodore Roosevelt state service of 1903 comprised nine-piece place settings; the Truman (1951) and Clinton (2000) state services had twelve; and the Wilson (1918), Franklin Roosevelt (1934), and Reagan (1981) state services all had sixteen, with only chop plates or platters ordered as matching serving pieces.[31] This consistency suggests a continuous White House tradition of serving formal meals in multiple courses using large, matching services.

FIG. 8. *Footed Dish*, 1866–67. Made by Lebeuf-Milliet and Company, Creil and Montereau, France (1840–1875); decorated by Félix-Joseph-Auguste Bracquemond (French, 1833–1914). Earthenware with printed and enamel decoration; height 3¹⁄₁₆ inches (7.8 cm), diameter 8⅝ inches (21.9 cm). Philadelphia Museum of Art. Gift of Mme Robert de Larosière, née Hugayte de Champfeu, 1979-52-2

This tradition persisted in the face of changing dining practices on less elite social levels. In 1911, one guide to table setting advised, "It is noticeable that dinner tables are far simpler than they have been for many years; there is less display of silver, cut glass, decorated china, and the like. Good taste demands a certain restraint in the use of these things."[32] Large matching services also remained unpopular. "In addition to your basic set of dishes," one guide counseled in 1956, "try collecting services for four or eight that will go with the regular dishes, mix and match with each other to give complete dinner table variety and special interest."[33] White House occasions, however, required greater formality than meals in private residences. For the first half of the twentieth century, dinners in the State Dining Room were served at long rectangular and E- or U-shaped tables, where diplomatic and social hierarchies could be maintained. As the author of a manual on table setting pointed out, "With the formal dinner, the etiquette is often elaborate. In Washington, for example, official society demands all sorts of distinctions which it considers extremely important, though most of us go through life knowing nothing about them."[34]

The majority of the state services supplied over the course of the twentieth century have remarkably similar, severely neoclassical designs, with bands of a single color and gold accented by simple geometric pat-

terns. The simpler types of wares that previously had been used by presidents and their families in less formal contexts were by the twentieth century prized even for official occasions. In discussing formal dinner tables in 1922, no less an authority than Emily Post declared:

> As though recovering from an illness, good taste is again demanding severe beauty of form and line, and banishing everything that is useless or superfluous. During the last twenty years most of us have sent an army of lumpy dishes to the melting-pot, and junky ornaments to the ash heap along with plush table covers, upholstered mantelboards and fern dishes! To-day we are going almost to the extreme of bareness.[35]

In their similarity, these designs also offered no sense of the individual chief executives' personalities. With the presidential seal rendered in gold relief as their principal decorative feature, these services celebrated the United States as a world superpower and the president as its corporate leader. Eleanor Roosevelt was criticized for adding a narrow band of roses and feathers derived from the Roosevelt family coat-of-arms to the design of the 1934 state service (cats. 168–73); such a detail was deemed inappropriate for the impersonal imagery of the presidency.[36] In contrast, the border of explosions or starbursts in gold relief on the Eisenhower service plates of 1955 (cat. 185) offered dramatic visual expressions of the militaristic fervor that characterized the United States at the height of the Cold War.

The notable exception to these impersonal designs was the state service commissioned in 1967 by Lady Bird Johnson (cats. 192–96). With borders of American wildflowers amid a dot pattern evoking rainfall surrounding the arms of the United States modeled on the 1817 Monroe state service, this service represented Mrs. Johnson's interests in conservation and White House history.[37] Moreover, the Johnson state service comprised only eight pieces for each place setting and two sizes of serving bowls. The reduced number of forms, more conducive to informal entertaining, as well as the more personal touches, represented a continuation of changes set in motion during the Kennedy administration. After her first state dinner in 1961, Jacqueline Bouvier Kennedy removed the long tables from the State Dining Room and replaced them with more informal round tables for eight or ten diners (fig. 9), often spreading these into the Blue Room to accommodate more guests.[38] Her interest in White House history also inspired her to use nineteenth-century tableware such as the Lincoln and Benjamin Harrison services for occasions with fewer guests, a practice continued by Lady Bird Johnson.

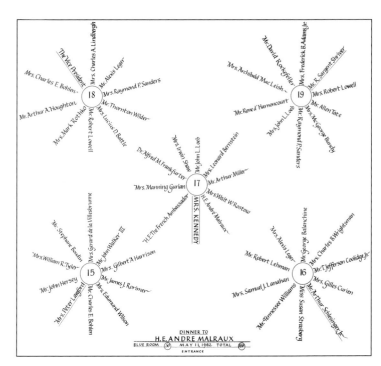

FIG. 9. Seating chart for a state dinner in the Blue Room of the White House, May 11, 1962, honoring French minister of culture André Malraux. (Courtesy of the John F. Kennedy Presidential Library and Museum, Boston)

The twentieth-century state services were much larger in scale than their predecessors. In part this reflected the larger number of guests that could be accommodated after the State Dining Room was enlarged during the White House renovations undertaken for Theodore Roosevelt by McKim, Mead, and White in 1902.[39] Monroe's dinner and dessert services had been for thirty people; the remaining nineteenth-century services were intended for sixty to eighty people and numbered between four and six hundred individual pieces. In contrast, the Theodore Roosevelt, Wilson, Franklin Roosevelt, and Truman services all included place settings for 120 people, averaging 1,590 pieces per service. The Lyndon Johnson state service of 1967 included 2,208 pieces for 216 place settings; the 2000 Clinton service had 3,600 pieces for 300 place settings; and the 1981 Reagan service comprised 4,370 pieces for 220 place settings and was larger than all the nineteenth-century state services combined. It should be noted that the Johnson and Reagan services were purchased with private funds, whereas the previous sets were bought with government appropriations for White House furnishings.

Presidential Tableware: From Exemplars to Collectibles

From 1788 onward, the First Family's role as tastemakers has been enormous. Regarding the porcelain table ornaments he had purchased for the president in Paris in 1790 (cats. 19, 20), Gouverneur Morris wrote Washington, "I think it of very great important to fix the taste of our country properly, and I think your example will go very far in that respect."[40] Imitations of state service patterns seem to have been made as early as the 1850s. A version of a dessert plate from the 1846 Polk state service without the relief ornament (cat. 66) may have been available commercially, although its traditional history indicates it was used at the White House during the Buchanan administration.[41] Later nineteenth-century copies of plates from the 1861 Lincoln and the Grant state services also exist (cats. 86, 103), suggesting a ready market for reproductions.[42] Tressemanes and Vogt, makers of the 1891 Benjamin Harrison state service, apparently retained the right to manufacture the design for sale to the general public and even used it for forms not ordered by the White House.[43]

The state service designed by Theodore R. Davis for Rutherford and Lucy Hayes had considerable impact on American taste upon its delivery in 1879. It became the subject of intense interest to critics and the public alike, so much so that in 1892 the antiquarian Alice Morse Earle was moved to comment, "Of the beautiful and costly set ordered by Mrs. Hayes too much is known, and too many cheaper copies have been sold, and may be seen in any large china-shop, to make it worth while to give any detailed description here."[44] Davis assigned Haviland the right to manufacture tableware from his designs for sale to the public for seven years. The company aggressively marketed the Davis/Hayes wares, even producing a booklet describing the imagery.[45] Examples of the oyster, soup, dinner, and fruit plates survive with various retailers' marks (cats. 136, 137), indicating that these forms were offered widely. One dinner platter in the McNeil Collection (cat. 131) was purchased in November 1882 by a John A. Rice at Haviland and Company's Barclay Street store in New York, accompanied by an affidavit that the platter was "an exact duplicate of the piece made by us for the U.S. Government in 1880 for the State Dinner Service at the Executive Mansion, and is equal to the original in every respect."[46]

As this document indicates, presidential patronage was a very important marketing tool, even for French ceramics firms. Haviland and Company eagerly sought the commission for the Hayes service—which proved more costly than expected to produce—just as it had the 1867 Grant service and replacements for the 1861 Lincoln service.[47] Tressemanes and Vogt, manufacturers of the Harrison state service, advertised the arrival of "some new shapes of white ware for decoration, in which line this house does a large business," at the firm's New York retail office, Vogt and Dose, with the additional comment, "There has been quite a boom in this trade ... and the notoriety given to the White House china painted by Mrs. Harrison and purchased of Vogt & Dose, may in part account for the present activity."[48]

Presidential purchases were even more crucial to American manufacturers. While serving as president, Jackson ordered porcelain "designed for use during [my] stay at [my] country seat" from the Philadelphia factory of William Ellis Tucker (1800–1832), the nation's first large-scale porcelain manufacturer, although this commission was never completed due to a failure in firing the kiln. Tucker had unsuccessfully petitioned Jackson in 1830 to provide government support for his enterprise.[49] Eder V. Haughwout, whose New York china firm decorated imported blanks, exhibited two different plates at the 1853 New York Crystal Palace Exhibition painted with the initial "P" and the arms of the United States, hoping for a presidential commission. Franklin Pierce, who opened the exhibition on July 14, 1853, chose one of the two designs for the state service he ordered later that year; eight years later, the other design, with a change in the border color, was selected by Mary Lincoln for the first of two state services she purchased.[50] The native imagery of the Hayes service was celebrated as an American triumph, even if the service had to be made in France; in giving Davis leave from his job as an illustrator at *Harper's Weekly* to work on the designs, Fletcher Harper commented, "If the Messrs. Haviland are willing to make the set, you must make the designs, for such a work cannot be done without eventual benefit to American potters."[51] Lenox Incorporated, which became the premier American porcelain manufacturer after 1920, proudly advertised its role in manufacturing White House services. "Today Lenox dinner service products are to be found in homes of culture and refinement throughout the land," wrote George Holmes in 1924. "Indeed, the first American-made dinner service to grace the White House is composed of 1700 pieces of Lenox."[52]

Not all of the public interest in presidential tableware has been positive. Expensive ceramics, especially imported ones, frequently became fodder for political opponents to attack a president's patriotism and even his morals. In 1840, Whig congressman Charles Ogle of Pennsylvania asked of Democratic president Martin Van Buren: "What, sir, will the honest locofoco say to Mr. Van Buren for spending the People's cash

in FOREIGN FANNY KEMBLE GREEN FINGERCUPS in which to wash his pretty, tapering, soft, white, lily fingers, after dining on fricandeau de veau and omolette soufflé?"[53] First Ladies have been subjected to even harsher criticism, usually for extravagance that revealed their monarchical ambitions and blinded them to problems faced by ordinary citizens. Mary Todd Lincoln was famously criticized for lavish purchases after the outbreak of the Civil War. One Ohio newspaper commented:

> The china services . . . will admirably suit the mulberry-covered livery of her footmen, etc. in Washington and possibly may help very nicely to get rid of the apparently exhaustless $25,000 salary of Mr. Lincoln. . . . Should Jeff Davis get into the White House *par hasard*, in a manner as unexpected the brilliant silver service and the China sets, with their Solferino borders, would delight his troops, I fancy, as well as the viands thereupon.[54]

When the White House announced the order for the Reagan state service in 1981—unfortunately, on the same day that the federal government cut subsidies for lunch programs in public schools—the attacks on Nancy Davis Reagan were strikingly similar to those on Mary Lincoln 120 years earlier. "The shrieks of radical Democrats that your husband Ron's program is favoring the rich and against the poor is at the moment not having any general success," the editor of the *Manchester Union-Leader* warned. "But if you keep this lifestyle, it will, because it gives the impression of a modern-day Marie Antoinette." A letter to the *Washington Post* quipped, "Only in America could rich capitalists donate $209,000 to give us new people's china of the republic." In her memoirs, Reagan countered, "There's something about White House china that seems to rile people. . . . People want the White House to look great, but they don't want it to cost anything."[55]

As important as presidential porcelains were at the time of their purchase, they took on different meanings and value after they ceased to be used. Ceramics left the White House by a variety of means. Near the end of his second term in 1797, Washington observed with a note of weariness, "Nothing has been said relating to the Table Linnens, Sheeting, China and Glassware which was furnished at the expense of the United States because they have been worn out, broken, stolen and replaced at private expense over and over again."[56] Broken, cracked, or chipped objects were discarded, and those stolen from the Executive Mansion were more likely coveted as relics than for their actual value. As the number of usable objects from a given service decreased, a new service would be ordered. Changing aesthetic preferences also led to the disposal of unfash-

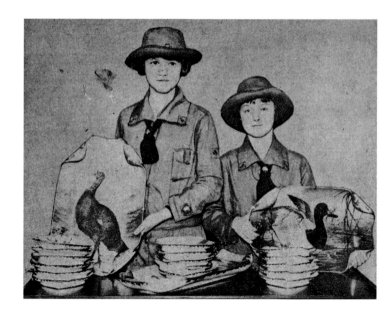

FIG. 10. "Presidential China Sold to Aid Girl Scouts," *Philadelphia Inquirer*, March 15, 1926. (Courtesy of Girl Scouts of Southeastern Pennsylvania Archive, Miquon, Pennsylvania)

ionable forms or styles. Upon assuming the presidency in 1881, Chester Arthur so disapproved of existing White House furnishings that he authorized the auction of twenty-four wagonloads of "unserviceable furniture" and thirty barrels of china (including cats. 41, 88). "Hardly a trace of the old White House taint [is] perceptible anywhere," an enthusiastic visitor reported in 1882.[57] By the early 1930s, when Victorian styles were out of favor, the 1879 Hayes state service was considered so unsuitable for use or even display that the Franklin Roosevelt administration donated pieces to the District of Columbia Girl Scouts to sell (fig. 10).

Even broken or unfashionable presidential ceramics have held great appeal for their tangible associations to historical figures and events, and from Washington's time on collectors have treasured them. A Chinese export plate with most of its overglaze decoration obliterated was preserved by a Washington, D.C., china restorer as "recovered from the debris after the British fired the White House on August the 24th. 1814" (cat. 36). Secretary of state and Massachusetts senator Daniel Webster (1782–1852) purchased plates owned by James Monroe (cats. 43–45), perhaps because Monroe had also served as secretary of state. The 1882 auction of "unserviceable furnishings" from the White House was advertised with the exhortation, "Some of the above are very antique, and the sale is worthy the attention of persons desiring souvenirs."[58]

Objects connected with George and Martha Washington have been particularly venerated. Examples of the "Cincinnati" (cats. 3–7) and "States" (cats. 12, 13) services removed during the Civil War from Robert E. Lee's family house at Arlington, Virginia, and stored with the U.S. Patent Office were displayed at the 1876 Centennial Exposition in Philadelphia.[59] Haviland and Company and other manufacturers made reproductions of the "States" service during the last quarter of the nineteenth century (cats. 14–16).[60] Museums, historic sites, and private collectors also sought Washington items. In 1878, for example, the Smithsonian Institution acquired a collection of ceramics owned by the Washingtons from their Lewis descendants.[61] The banker and art collector William Corcoran, who not coincidentally owned a Washington, D.C., auction house, acquired three English porcelain plates with a now-discounted tradition of ownership by George Washington and presented two of them to Mount Vernon in 1879 (see cat. 31).[62] Other examples from several private collections were loaned to the 1889 Centennial Exhibition of Washington's Inauguration in New York. One of the saucers from the Niderviller tea service (see cats. 17, 18) was exhibited at the Metropolitan Museum of Art in the 1890s as part of a gallery of images of Washington, Franklin, and Lafayette.[63]

A mania for collecting old pottery and porcelain swept the United States in the final decades of the nineteenth century, inspired in part by the Arts and Crafts notion that handcrafted objects were superior to manufactured wares. Collectors acknowledged the historical importance of presidential ceramics but excoriated their aesthetic qualities. Writing in 1878, the author of *The China Hunters Club* said of the "Cincinnati" and "States" services, which at the time were thought to be of French origin, "They do not seem to be remarkably good examples of the ceramic art of their period, which was one of great splendor in European factories; but these, so far as I am able to judge, are quite ordinary fabrics. . . . As ceramic specimens they have no value, but as historical relics they are priceless."[64] In discussing presidential ceramics twenty years later, Alice Morse Earle was equally severe: "The true china lover will . . . care little to own any piece of porcelain simply because it is said to have belonged to or was eaten from by some great man—if that be its only virtue."[65]

Not surprisingly, the pioneer collectors of presidential ceramics were more likely to be Washington insiders than aesthetes. Ben Perley Poore (1820–1887), who spent sixty years in Washington as editor of the *Congressional Directory*, clerk of the Senate committee on printing public records, and correspondent for the *Boston Journal*, formed an

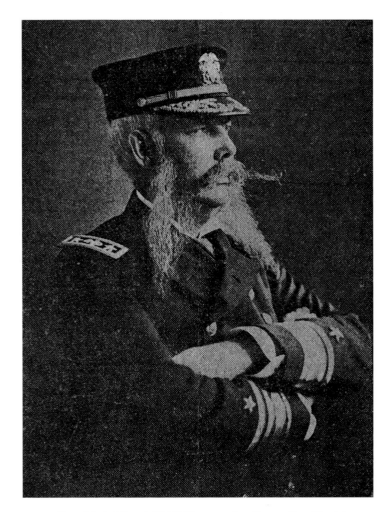

FIG. 11. Rear Admiral Francis W. Dickins, an early collector of presidential china. Dickins Scrapbook, Collection of Robert L. McNeil, Jr.

important collection of early American relics that included furniture owned by Washington and "some pieces of china from almost all the different administrations" (cats. 50, 51, 53).[66] William T. Crump, White House steward during the Hayes, Garfield, and Arthur administrations, amassed a significant collection of presidential ceramics that he later displayed in his Washington restaurant; some of these objects were acquired from the 1882 auction for which he had helped select the pieces to be sold (cats. 40, 41, 88, 89, 134).[67] Rear Admiral Francis W. Dickins (1844–1910; fig. 11) assembled a collection of 145 presidential pieces, many of which also came from the 1882 sale, and twenty of which are now in the McNeil Collection.[68]

Although she disapproved of collecting ceramics for purely historical associations, Alice Morse Earle nevertheless wanted to see presidential ceramics properly preserved for future generations: "It seems a pity that a few pieces of each of these 'state sets' should not have been preserved in a cabinet at the White House to show us the kind of china from which our early rulers ate their daily meals and served their state dinners, as well as to show our varying and halting progress in luxury, refinement, and taste."[69] In fact, even as Earle wrote, Caroline Scott Harrison had begun to sort through the miscellaneous pieces of old state services still at the White House, intending to create a display in the State Dining Room. Delayed by her premature death, a White House China Collection was finally established in 1904 by Edith Carow Roosevelt and today is the most complete representation of presidential ceramics.[70] Through the foresight and generosity of Robert L. McNeil, Jr., the Philadelphia Museum of Art is now able to exhibit the most comprehensive collection of these remarkable objects to be found outside of the nation's capital. The collection offers a glimpse into the simultaneously public and rarified world of presidential entertaining, with the accompanying changes in style, dining practices, and ceramic production, across three centuries of American history.

NOTES

1. The state services were ordered by Monroe (1817, cats. 38–42), Jackson (1833, cats. 50–53), Polk (1846, cats. 55–65), Pierce (1853, cats. 68–72), Lincoln (1861, cats. 73–79; 1865, cats. 87–92), Grant (1870, cats. 94–102), Hayes (1879, cats. 116–39), Benjamin Harrison (1891, cats. 145–50), Theodore Roosevelt (1903, cats. 159–61), Wilson (1918, cat. 165), Franklin Roosevelt (1934, cats. 168–73), Truman (1951, cats. 179–82), Eisenhower (1955, cat. 185), Lyndon Johnson (1968, cats. 192–96), Reagan (1981), and Clinton (2000). The Reagan and Clinton services are not represented in the McNeil Collection.

2. Margaret Brown Klapthor et al., *Official White House China, 1789 to the Present*, 2d ed. (New York: Harry N. Abrams, 1999), p. 189.

3. John Webster Keefe, *Paris Porcelains in the New Orleans Museum of Art* (New Orleans: New Orleans Museum of Art, 1998), pp. 30–31.

4. Charles L. Venable et al., *China and Glass in America, 1880–1980: From Tabletop to TV Tray* (New York: Harry N. Abrams for the Dallas Museum of Art, 2000), p. 193.

5. For Tressemanes and Vogt, see Aileen Dawson, *A Catalogue of French Porcelain in the British Museum* (London: British Museum Press, 1994), p. 316; Venable et al., *China and Glass in America*, p. 186.

6. The 1857 New York City directory lists a second address for Haughwout at "24 Rue de Paradis, Paris"; in 1858 and subsequent directories this is given as "24 Rue des Parades." Between 1866 and 1869 it changed to 35 Rue d'Hautville

7. For the development of the porcelain industry in the United States, see Alice Cooney Frelinghuysen, *American Porcelain, 1770–1920* (New York: The Metropolitan Museum of Art, 1989), pp. 52–58; Venable et al., *China and Glass in America*, pp. 117–30.

8. Klapthor et al., *Official White House China*, p. 146.

9. For the details of these purchases, see ibid., pp. 68–69, 104–5.

10. Ibid., p. 87; the present location of this service is unknown.

11. Svend Eriksen and Geoffrey de Bellaigue, *Sèvres Porcelain: Vincennes and Sèvres, 1740–1800* (London: Faber and Faber, 1987), pp. 348–49.

12. The invoices for the Monroe and Jackson services are transcribed in Klapthor et al., *Official White House China*, pp. 43, 56–57; illustrations of other serving forms from the Monroe service are in ibid., pp. 43–44.

13. Marie G. Kimball, *Martha Washington Cook Book* (New York: Coward-McCann, 1940), pp. 28–29.

14. Ibid.

15. Louie Conway Belden, *The Festive Tradition: Table Decoration and Desserts in America, 1650–1900* (New York: W. W. Norton, 1983), p. 21.

16. Mrs. Benjamin Stoddert to her sister, 1799, quoted in Robert C. Alberts, *The Golden Voyage: The Life and Times of William Bingham, 1752–1804* (Boston: Houghton Mifflin, 1969), p. 359.

17. Belden, *The Festive Tradition*, pp. 33–35.

18. Catharine Sedgwick, *Letters from Abroad to Kindred at Home* (New York: Harper and Brothers, 1841), vol. 1, p. 213.

19. Mrs. James Dixon, diary entry for December 19, 1845, Connecticut Historical Society, quoted in Klapthor et al., *Official White House China*, p. 68.

20. *The Diary of Philip Hone, 1828–1851*, 2 vols., ed. Allan Nevins (New York: Dodd, Mead, 1927), vol. 2, p. 462.

21. Juliet Corson, *Miss Corson's Practical American Cookery and Household Management* (New York: Dodd, Mead, 1885), quoted in Belden, *The Festive Tradition*, p. 38; a late example of these styles being offered as options is Lilian M. Gunn, *Table Service and Decoration* (Philadelphia: J. B. Lippincott, 1928), pp. 52, 59, 62.

22. Belden, *The Festive Tradition*, p. 37.

23. Susan Williams, *Savory Suppers and Fashionable Feasts: Dining in Victorian America* (New York: Pantheon, 1985), pp. 80–81.

24. The invoice for this service is transcribed in Klapthor et al., *Official White House China*, p. 77; other serving forms are illustrated in ibid., pp. 78–79.

25. The invoices for the Lincoln service are transcribed in ibid., pp. 84–85; different forms are illustrated in ibid., pp. 86–88.

26. William C. Prime, *Pottery and Porcelain of All Times and Nations* (New York: Harper and Brothers, 1878), p. 409.

27. *The Successful Housekeeper* (Detroit: M. W. Ellsworth, 1882), p. 468.

28. Theodore R. Davis to Webb Hayes, February 26, 1879, quoted in Klapthor et al., *Official White House China*, p. 105.

29. For further information on Bracquemond's designs for ceramics, see Jean d'Albis, *Haviland* (Paris: Dessain et Tolra, 1988), pp. 30–33; and Gabriel P. Weisberg et al., *Japonisme: Japanese Influence on French Art, 1854–1910* (Cleveland: Cleveland Museum of Art, 1975), pp. 157–58.

(H. Wilson, comp., *Trow's New York City Directory* [New York: John F. Trow], 1857, p. 365; 1858, p. 353; 1866, p. 440).

30. The invoices for the Hayes service are transcribed in Klapthor et al., *Official White House China*, pp. 111–13, 117; the sauceboat is illustrated on p. 112.

31. The invoices for these services are transcribed in ibid., pp. 149, 157, 161–62, 166, 184–85.

32. Caroline French Benton, *Easy Entertaining* (Boston: Dana Estes, 1911), p. 14.

33. *Better Homes and Gardens Decorating Book* (Des Moines, Iowa: Meredith Publishing Co., 1956), n.p.

34. Amelia Leavitt Hill, *The Complete Book of Table Setting, with Service, Etiquette, and Flower Arrangement* (New York: Greystone Press, 1949), p. 115.

35. Emily Post, *Etiquette in Society, in Business, in Politics, and at Home* (New York: Funk and Wagnalls, 1922), pp. 191–92.

36. For criticism of the Franklin Roosevelt service, see Klapthor et al., *Official White House China*, p. 162.

37. For the Johnson service, see Adam Lewis, *Van Day Truex: The Man Who Defined Twentieth-Century Taste and Style* (New York: Viking Studio, 2001), pp. 199–201. The invoice for the service is transcribed in Klapthor et al., *Official White House China*, p. 177.

38. James A. Abbott and Elaine M. Rice, *Designing Camelot: The Kennedy White House Restoration* (New York: Van Nostrand Reinhold, 1998), pp. 6–7; Letitia Baldrige with René Verdon, *In the Kennedy Style: Magical Evenings in the Kennedy White House* (New York: Madison Press, 1998), pp. 29–31.

39. For the renovation, see Betty C. Monkman, *The White House: Its Historic Furnishings and First Families* (New York: Abbeville Press for the White House Historical Association, 2000), pp. 185–87.

40. Morris to Washington, January 14, 1790, in *The Diary and Letters of Gouverneur Morris*, ed. Anne Cary Morris, 2 vols. (New York: Charles Scribner's Sons, 1888), vol. 1, pp. 270–71.

41. Klapthor et al., *Official White House China*, p. 294.

42. Margaret Brown Klapthor, *White House China of the Lincoln Administration in the Museum of History and Technology*, Paper 62, Contributions from the Museum of History and Technology (Washington, D.C.: Smithsonian Institution Press, 1967), pp. 119–20.

43. Klapthor et al., *Official White House China*, pp. 190, 230.

44. Alice Morse Earle, *China Collecting in America* (New York: Charles Scribner's Sons, 1892), p. 255.

45. Haviland and Company, *The White House Porcelain Service: Designs by an American Artist, illustrating exclusively American Fauna and Flora* (New York, 1880), reproduced in Klapthor et al., *Official White House China*, pp. 201–88.

46. Invoice, Haviland and Company, New York, to John A. Rice, November 9, 1882. Archives of the American Art Department, Philadelphia Museum of Art.

47. D'Albis, *Haviland*, p. 27, illustrates the Lincoln service as one of "quelques-uns des services créés par Haviland pour les *Présidents des Etats-Unis*" [some of the services made by Haviland for Presidents of the United States], although the earliest documented Haviland pieces for the Lincoln service were produced as replacements in 1873; see Klapthor et al., *Official White House China*, pp. 99–100.

48. *China, Glass and Lamps*, March 9, 1892, cited in Klapthor et al., *Official White House China*, p. 131.

49. Copy of a letter, William Ellis Tucker to General Andrew Jackson, July 13, 1830, in Benjamin Tucker, *Letter Book*, vol. 3, *1829–1831*, Philadelphia Museum of Art, 1951-17-21(8); for Tucker, see Philip H. Curtis, "The Production of Tucker Porcelain, 1826–1838: A Reevaluation," in *Ceramics in America*, ed. Ian M. G. Quimby (Charlottesville: University Press of Virginia for the Henry Francis du Pont Winterthur Museum, 1973), pp. 339–74.

50. Klapthor et al., *Official White House China*, pp. 76–77.

51. Theodore R. Davis, "The White House Porcelain Service for State Dinners," *Ladies' Home Journal* (July 1889), p. 4.

52. George Sanford Holmes, *Lenox China: The Story of Walter Scott Lenox* (privately printed, 1924), p. 29.

53. Quoted in Monkman, *The White House*, p. 94.

54. Editorial, *Crisis* (Columbus, Ohio), May 30, 1861, quoted in Klapthor et al., *Official White House China*, p. 84.

55. William Loeb, editorial in the *Manchester Union-Leader*, as quoted in Kitty Kelley, *Nancy Reagan: The Unauthorized Biography* (New York: Simon and Schuster, 1991), p. 316; Carlos E. Kruytbosch, letter to the editor, *Washington Post*, September 18, 1981, p. A28; Nancy Reagan with William Novak, *My Turn: The Memoirs of Nancy Reagan* (New York, 1989; large-print edition, Thorndike, Me.: Thorndike Press, 1990), p. 60.

56. Quoted in Jane Shadel Spillman, *White House Glassware: Two Centuries of Presidential Entertaining* (Washington, D.C.: White House Historical Association, 1989), p. 19.

57. Monkman, *The White House*, pp. 161–62.

58. Advertisement for Duncanson Brothers Auctioneers, April 1882, reproduced in ibid., p. 161.

59. Annie Trumbull Slosson, *The China Hunters Club* (New York: Harper and Brothers, 1878), p. 145.

60. D'Albis, *Haviland*, p. 27.

61. Earle, *China Collecting in America*, p. 240.

62. Susan Gray Detweiler, *George Washington's Chinaware* (New York: Harry N. Abrams, 1982), pp. 144, 146.

63. See Earle, *China Collecting in America*, pp. 244–45, who records it as a loan from J. Chester Lyman; and Arthur Hoeber, *The Treasures of The Metropolitan Museum of Art of New York* (New York: R. H. Russell, 1899), p. 144.

64. Slosson, *The China Hunters Club*, p. 145.

65. Earle, *China Collecting in America*, p. 249.

66. For Poore, see Elizabeth Stillinger, *The Antiquers* (New York: Alfred A. Knopf, 1980), pp. 27–34; the quotation is from an April 1925 newspaper article cited on p. 33.

67. For accounts of souvenir taking, see Monkman, *The White House*, pp. 105, 133, and passim.

68. Francis W. Dickins, *Catalogue of the Dickins Collection of American Historical China* (Washington, D.C.: privately printed, 1898).

69. Earle, *China Collecting in America*, pp. 255–56.

70. Klapthor et al., *Official White House China*, pp. 9–10; Monkman, *The White House*, pp. 195–97.

AMERICAN PRESIDENTIAL CHINA

SUSAN GRAY DETWEILER

Porcelain services used during the administrations of American presidents are known as "presidential china." Services purchased for official use in the President's House evoke images of distinguished gatherings of diplomats, celebrities, and royalty at the national "First Table," while the family services disclose the personal taste, origins, and status of particular presidents and first ladies. These relics are, therefore, part of our national heritage, providing material evidence for various aspects of American cultural and social history.

The Robert L. McNeil, Jr., American Presidential China Collection at the Philadelphia Museum of Art includes porcelain acquired during twenty-six presidential administrations. Some administrations are not represented by state services in the collection or in this catalogue because dining china purchased for the White House is used until breakage or evolving fashion brings about the need for a new set. Today, for example, the president might serve a state dinner with china purchased during the Truman, Johnson, or Reagan administrations. Examples from several more recent administrations are not included here because the sale of White House china to the public has not been permitted since the administration of Theodore Roosevelt.

Beginning in the early nineteenth century, however, collectors could purchase discarded porcelain in sales of "decayed furnishings" from the White House. Private collections were also augmented by presidential memorabilia received as gifts or purchased at estate sales. Among the early collectors was Caleb Lyon (1821–1875), U.S. Consul to Shanghai, Congressman, and Territorial Governor of Idaho, whose "Collection of Oriental and Occidental Ceramics," including thirty-five lots of "Presidential Porcelain," was sold at auction in New York in 1876.[1] Other nineteenth-century collectors included Ben Perley Poore (1820–1887), a prominent Washington journalist, and William T. Crump (b. 1841), steward at the White House from 1879 to 1882, who purchased many pieces at a sale of White House discards on April 15, 1882[2] and displayed them at his restaurant, the Garfield Dining Rooms in Washington, D.C.

Admiral Francis W. Dickins (1844–1910), also of Washington, D.C., assembled a collection of presidential china, which was displayed at the Smithsonian Institution from 1913 to about 1935.[3] A number of pieces in the McNeil Collection were once owned by these early collectors.

Robert L. McNeil, Jr., began his collection in 1960 with the purchase of a Chinese export porcelain plate from George Washington's "Order of the Cincinnati" service from Matthew and Elizabeth Sharpe of Barren Hill, Pennsylvania (cat. 6). Subsequently, many pieces were acquired from earlier collectors such as Dorothy S. Waterhouse of Boston; Marjorie W. Hardy of Providence; Stanley S. Wohl of Annapolis, Maryland; and the heirs of Admiral Dickins. Others were purchased from dealers such as Elinor Gordon of Villanova, Pennsylvania, and Frank Klapthor and Michael Arpad, both of Washington, D.C. Occasionally, pieces have been acquired by trade with other collectors, including Set C. Momjian of Philadelphia.

Selections from the McNeil Collection were included in the nine-venue exhibition *American Presidential China*, organized by the Smithsonian Institution Traveling Exhibition Service in 1976, and have been exhibited at the Philadelphia Museum of Art, the White House, Mount Vernon, the Hermitage in Nashville, and the Musée du Luxembourg, Paris. Examples from the Collection have been published in books and catalogues, including Margaret Klapthor's *Official White House China* (1975) and the revised edition, which includes contributions from Betty Monkman, William Allman, and Susan Gray Detweiler (1999), as well as in *American Presidential China* (1975) and *George Washington's Chinaware* (1982), both by Detweiler.

When asked about his motives for forming the collection, McNeil replied that, after purchasing George Washington's "Order of the Cincinnati" plate, it occurred to him that presidential china not only recorded our country's social and political development, special occasions, and visits by notable personages, but also represented the evolution of our national taste and culture through more than two centuries.

GEORGE WASHINGTON (1732–1799)
President, 1789–97

The first American president acknowledged the social importance of a fashionably equipped dining table as early as 1757 when, as a young bachelor, he ordered "fine china dishes" from an English merchant.[4] Throughout his lifetime of public service and private occupation, George Washington participated substantially in matters of domestic taste and style. Memorabilia, including porcelains, from the Washington household have descended through the grandchildren of Martha Washington: Eliza Parke Custis Law (1776–1832), Martha Parke Custis Peter (1777–1854), Eleanor "Nelly" Parke Custis Lewis (1779–1852), and George Washington Parke Custis (1781–1857).

Chinese Export Porcelain

An English merchant first shipped Chinese export porcelain decorated with underglaze-blue landscapes or floral compositions to Mount Vernon in 1762. The Washingtons purchased "blue-and-white" ware at least nine times during the following thirty-five years. Mrs. Washington bequeathed the "blue and white china in common use" to her granddaughter, Eleanor Parke Custis Lewis (cat. 1).[5]

CAT. 1. *Octagonal Plate,* c. 1780*

Porcelain with gilt and underglaze blue decoration; "Isles of the Blest" pattern; diameter 9 inches (22.9 cm)
LABELS: [written on three blue-bordered paper labels] *Blue Indian China plate / 1 of George Washingtons / Breakfast set / this plate given [to] Mrs James Monroe / by Mrs Lewis niece of / Mrs Washingtons at / (Woodlawn) the Lewis*
PROVENANCE: Eleanor Parke Custis (Mrs. Lawrence) Lewis (1779–1852), granddaughter of Martha Washington; Elizabeth Kortright (Mrs. James) Monroe (1768–1830); private collector; sold at Christie's, New York, June 16, 1984, lot 131
2006-3-28

CAT. 2. *Ginger Jar,* c. 1780*

Porcelain with underglaze blue decoration; sterling silver rim added later; "Fitzhugh" motifs; height 7³⁄₁₆ inches (18.3 cm), diameter 8 inches (20.3 cm)
PROVENANCE: Martha Parke Custis (Mrs. Thomas) Peter (1777–1854), granddaughter of Martha Washington; by descent to the Walter Peter family, Georgetown; acquired 1986
2006-3-33

CAT. 1

CAT. 2

Table and Tea Service, 1785

Chinese; porcelain with enamel, gilt, and underglaze blue decoration

Colonel Henry ("Lighthorse Harry") Lee (1756–1818) purchased a 302-piece Chinese export porcelain table and tea service in New York in 1786 for his friend, George Washington. Each piece was decorated with an underglaze blue "Fitzhugh" border, an enameled figure of Fame, and the eagle emblem of the Society of the Cincinnati. In 1783, General Washington had become the first president of the Society, an association of former officers in the American Revolution. The "Cincinnati" china arrived in New York in May 1785 aboard the *Empress of China*, the first American ship to trade directly with Canton.[6] The service was used in at least two of the three presidential residences in New York and Philadelphia as well as at Mount Vernon (cats. 3–7).

Other later examples, made for founding members of the Society of the Cincinnati, were acquired for comparison to the earlier Washington service. These Chinese export porcelains were decorated about 1790 with various configurations of Society of the Cincinnati motifs (cats. 8–11).

CAT. 3

CAT. 3. *Sauce Tureen and Cover**

Height 4¾ inches (12.1 cm), width 7⅛ inches (18.1 cm), depth 5 inches (12.7 cm)
PROVENANCE: George Washington Parke Custis (1781–1857), grandson of Martha Washington, Arlington, Virginia; to his granddaughter, Mary Custis Lee (1835–1918), Washington, D.C.; Bruce Perkins, Middleburg, Virginia; Elinor Gordon, Villanova, Pennsylvania; acquired 1981
PUBLISHED: Detweiler 1982, p. 89, pl. 70; Klapthor 1999, p. 22
2006-3-21a,b

CAT. 4. *Platter*

Length 14⅛ inches (35.9 cm)
PROVENANCE: Elinor Gordon, Villanova, Pennsylvania; acquired 1964
2006-3-2

CAT. 5. *Soup Plate*

Diameter 9½ inches (24.1 cm)
PROVENANCE: Charles Harrison; private collector, Richmond, Virginia; sold at Sloan's Auction Galleries, North Bethesda, Maryland, April 2–4, 1993, lot 2608
2006-3-34

CAT. 6. *Plate**

Diameter 9½ inches (24.1 cm)
PROVENANCE: Caleb Lyon (1822–1875); Luther Kountze (1841–1918); Stanley S. Wohl (1895–1978), Annapolis, Maryland; Frances Clemson Cross (d. 1960), White Plains, New York; Matthew and Elizabeth Sharpe, Barren Hill, Pennsylvania; sold at Spring Mill Antiques, Conshohocken, Pennsylvania; acquired 1960
PUBLISHED: Detweiler 1975, back cover
2006-3-1

CAT. 7. *Saucer*

Diameter 4¹⁵⁄₁₆ inches (12.6 cm)
PROVENANCE: The Skaliy Collection, Atlanta; sold at Sotheby Parke Bernet, New York, November 20, 1980, lot 536
2006-3-20

CAT. 8. *Plate*, c. 1790

From a service decorated for Henry Knox (1750–1806); diameter 7¹¹⁄₁₆ inches (19.6 cm)
PROVENANCE: Scott Bartlett, Greenwich, Connecticut; sold at Sotheby's, New York, January 31, 1985, lot 300
2006-3-29

CAT. 9. *Saucer,* c. 1790

From the first service decorated for William Eustis (1753–1825); diameter 5⁹⁄₁₆ inches (14.1 cm)
LABEL: [printed] *454*
PROVENANCE: Edmund W. Mudge, Jr. (1900–1985), Dallas; sold at Christie's, New York, May 22, 1985, lot 155
2006-3-32

CAT. 10. *Saucer,* c. 1795

From the second service decorated for William Eustis (1753–1825); diameter 5½ inches (14 cm)
PROVENANCE: Massachusetts collector; sold at Sotheby's, New York, January 31, 1985, lot 301
2006-3-30

CAT. 11. *Breakfast Teabowl,* c. 1790

From a service decorated for Colonel Constant Freeman (1757–1824); height 2⅛ inches (5.5 cm), diameter 4¼ inches (10.8 cm)
LABEL: [printed] *RAFI Y. MOTTAHEDEH / COLLECTION,* [handwritten] *34*
PROVENANCE: Mr. and Mrs. Rafi Y. Mottahedeh; sold at Sotheby's, New York, January 30, 1985, lot 285
2006-3-31

Cabinet Service, 1796

Chinese; designed by Andreas Everardus van Braam Houckgeest (Dutch, 1739–1801); porcelain with enamel, gilt, and underglaze blue decoration

The Dutch trader Andreas van Braam Houckgeest brought a porcelain service from Canton to Philadelphia in 1796 in a box labeled "for Lady Washington."[7] Specifically designed for Mrs. Washington by Van Braam, each piece of the service displays Van Braam's program of enameled symbolic motifs, including the serpent swallowing its tail (a symbol for eternity), a strong chain of fifteen states copied from Benjamin Franklin's design for colonial Pennsylvania currency, a Latin motto about strength and glory from Vergil's *Aeneid,* and Martha Washington's monogram on a glorified golden disk. Originally comprising about forty pieces, the service was intended primarily for display. The forms included a covered two-handled cup, also called a chocolate or caudle cup, made in China for export to the Dutch market by 1700. Sèvres called the form *tasse à la reine,* and it was made in England by the New Hall, Caughley, Derby, and other factories late in the eighteenth century. Today, fewer than twenty pieces of this service are known (cats. 12, 13).

The popularity of the Martha Washington "States" china inspired numerous reproductions by French, English, and American manufacturers from the last quarter of the nineteenth century to the present (cats. 14–16).

CAT. 12. *Caudle Cup with Cover and Saucer**

Height of cup 4¹⁵⁄₁₆ inches (12.6 cm), diameter of saucer 6⁵⁄₁₆ inches (16.1 cm)
LABELS: [handwritten and attached inside cup] *The* [MW monogram] *China was presented to Mrs. Washington by / General Washington's early friend Van Braam;* [printed and attached inside cup and on saucer] *24*
PROVENANCE: Martha Parke Custis (Mrs. Thomas) Peter (1777–1854), granddaughter of Martha Washington; by descent to the Walter Peter family, Georgetown; acquired 1979
2006-3-14a,b, 15

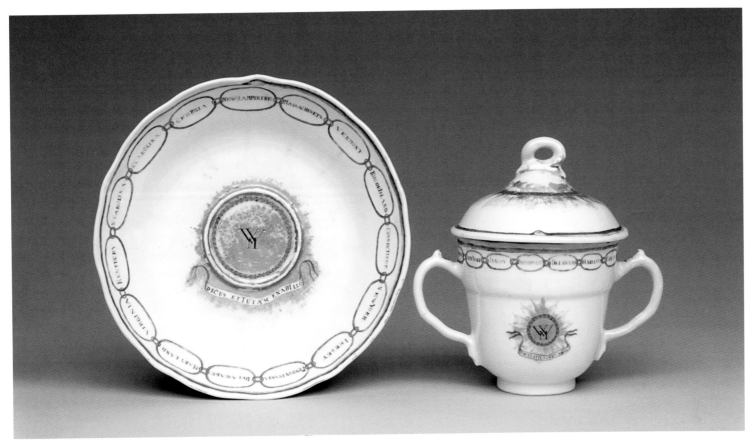

CAT. 13. *Plate**

Diameter 9⅜ inches (23.8 cm)
PROVENANCE: George Washington Parke Custis (1781–1857), grandson of Martha Washington, Arlington, Virginia; to his daughter, Mary Custis (Mrs. Robert E.) Lee (1835–1918), Washington, D.C.; Admiral Francis W. Dickins (1844–1910), Washington, D.C.; Edith Pratt Dickins; Philip Pratt; Charles H. Cox; Charles H. Cox, Jr., Paoli, Pennsylvania; acquired 1972
PUBLISHED: Detweiler 1975, front cover; Detweiler 1982, p. 157, pl. 136
2006-3-7 (*illustrated on p. 2)

CAT. 14. *Plate*, c. 1893–1926

French, made in Limoges, porcelain with printed, enamel, and gilt decoration; diameter 8¾ inches (22.2 cm)
MARK: [printed in green] *LIMOGES / FRANCE*
PROVENANCE: Mrs. Virginia Beecher-Smith, Binghamton, New York; sold at Sotheby Parke Bernet Galleries, New York, May 20, 1967, lot 28
2006-3-3

CAT. 15. *Plate*, c. 1900–1926

English; earthenware with gilt and printed underglaze blue decoration; diameter 9⅛ inches (23.2 cm)
MARKS: [printed in blue] *MADE IN ENGLAND / FOR / REMICK FURNITURE / Cº. / MILFORD, MASS.*; [impressed] *91/608*
PROVENANCE: Dorothy S. Waterhouse (1894–1982), Boston; acquired 1976
2006-3-8

CAT. 16. *Cup*, c. 1926; *Saucer*, c. 1895

English; porcelain with printed, enamel, and gilt decoration; height of cup 2⅝ inches (6.7 cm), diameter of saucer 5½ inches (14 cm)
MARKS: [printed in green on cup] *ENGLAND*; [printed in red on saucer] *DULIN & MARTIN CO. / WASHINGTON, D.C.*
PROVENANCE: Marjorie W. Hardy (1908–1992), Providence, Rhode Island; acquired 1972
2006-3-5, 6

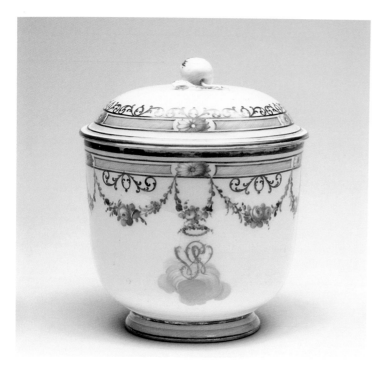

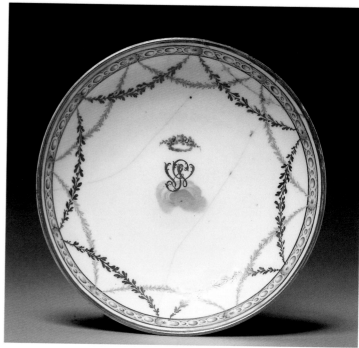

CAT. 17

CAT. 18

Tea and Coffee Service, c. 1781

French, made by Niderviller factory, Niderviller (1749–present);
porcelain with enamel and gilt decoration

Adam Philippe, comte de Custine (1740–1793), proprietor of the Niderviller factory near Strasbourg, France, and an officer serving under Rochambeau in the American Revolution, presented a French porcelain tea and coffee service to Martha Washington at Mount Vernon in 1782. The service comprised typical Continental porcelain forms decorated with a variety of scrolled and floral enameled and gilt borders surrounding a cipher of George Washington's initials below a chaplet of roses. A slop bowl, cream jug, teabowls, and coffee cups from this service are at Mount Vernon.[8]

CAT. 17. *Sugar Bowl and Cover**

Height 5 inches (12.7 cm), diameter 4¼ inches (10.8 cm)
MARKS: [painted in black] *CC* [interlaced] / [line] / *Nº. 29*
LABEL: [printed] *22*
PROVENANCE: Martha Parke Custis (Mrs. Thomas) Peter (1777–1854), granddaughter of Martha Washington; by descent to the Walter Peter family, Georgetown; acquired 1976
2006-3-9a,b

CAT. 18. *Saucer**

Diameter 5³⁄₁₆ inches (13.2 cm)
MARKS: [painted in black] *CC* [interlaced] / [line] / *Nº. 49 / F. N. 5*
LABELS: [printed] *284*; [printed] *W. P. HARBESON / NO /* [handwritten] *F. N. 5 / NIDERV*
PROVENANCE: Dr. William P. Harbeson (1882–1972), Philadelphia; New Jersey collector; sold at Sotheby's, New York, January 26, 1984, lot 175
2006-3-23

French Biscuit-Porcelain Figures

President Washington purchased French biscuit-porcelain figures in New York and Philadelphia to ornament official dinners, but the most important ensemble of classical deities, comprising three complex figural groups and twelve individual figures (including cats. 19, 20), was purchased for the President in 1790 at Guérhard and Dihl's Duc d'Angoulême factory in Paris by Gouverneur Morris (1752–1816), who was in Paris to negotiate American tobacco sales. Aware of social precedents to be set in the nation's first presidency, Morris wrote to President Washington, "I think it of very great importance to fix the taste of our Country properly, and I think your Example will go so very far in that respect."[9] On the President's dining table, these figures were arranged symmetrically on a central silver-and-glass *surtout-de-table*. Other biscuit-porcelain figures (cats. 21, 22), singly and in pairs, may have been used on tables, shelves, or mantels. The posture of the season figures suggests that they were intended for a mantel or high shelf.

CATS. 19, 20

CATS. 19, 20. *Flora* and *Minerva*, c. 1789*

Made by Dihl et Guérhard, Paris (1781–1828); unglazed porcelain; height of *Flora* 6 inches (15.2 cm), diameter of base 1¹³⁄₁₆ inches (4.6 cm); height of *Minerva* 7 inches (17.8 cm), diameter of base 1⅞ inches (4.8 cm)
LABEL: *Minerva* formerly had a paper label printed with *12* attached to the front of its base (Detweiler 1982, fig. 89)
PROVENANCE: Martha Parke Custis (Mrs. Thomas) Peter (1777–1854), granddaughter of Martha Washington; by descent to the Walter Peter family, Georgetown; acquired 1984
PUBLISHED: Detweiler 1982, p. 112, pl. 89
2006-3-24, 25

CATS. 21, 22. *Spring* and *Autumn*, c. 1785–90*

Made by Niderviller factory, Niderviller (1749–present); porcelain; height of *Spring* 6⁹⁄₁₆ inches (16.7 cm), diameter of base 2⅜ inches (6 cm); height of *Autumn* 6½ inches (16.5 cm), diameter of base 2⅝ inches (6.7 cm)
MARKS: [incised on back of base of *Spring*] *E·N° 6*; [incised on back of base of *Autumn*] *E N° 70*; [in raised letters on back of base of *Autumn*] *NIDERVILLE[R]*
LABELS: [handwritten on both] V^n
PROVENANCE: Martha Parke Custis (Mrs. Thomas) Peter (1777–1854), granddaughter of Martha Washington; by descent to the Walter Peter family, Georgetown; acquired 1984
PUBLISHED: Detweiler 1982, p. 115, pl. 92
2006-3-26, 27

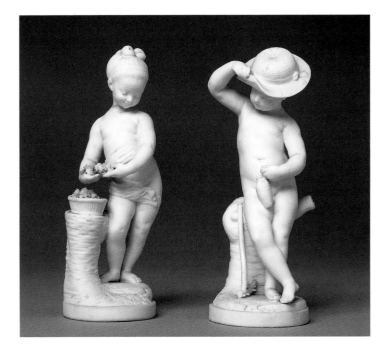

CATS. 21, 22

French Porcelain Table, Tea, and Dessert Wares

President and Mrs. Washington served important banquets on pristine white French porcelain embellished only with gold dentate borders and accents. The service originally was assembled over a period of years by purchase from Sèvres and other factories in 1778 and later by Eléonore-Françoise-Elie, comte de Moustier (1751–1817), the French ambassador to the United States.[10] President Washington purchased the porcelain from the French legation in New York in March 1790 after the comte de Moustier was recalled to France. Among the 309 pieces listed on the invoice were eight "cocottes" (cat. 23), four "butter boats" (cat. 24), two "iceries compleat" (cat. 28), and thirty-six "ice pots" (cat. 29).[11] The dessert chiller cover matches another that survives with its base in the Peter collection at the Smithsonian National Museum of American History in Washington, D.C. The latter bears the mark of Jean-Baptiste Locré's factory of "German porcelain." President Washington used this porcelain for official entertaining in New York and Philadelphia and for "genteel" dinners at Mount Vernon upon his retirement in 1797.

CAT. 23. *Casserole*, c. 1785*

Made by Comte d'Artois factory, Paris (1779–1789); porcelain with gilt decoration; height 3 inches (7.6 cm), length (including handle) 15 inches (38.1 cm), diameter 7¼ inches (18.4 cm)
MARK: [painted in black] *C.D.*
LABELS: [printed on separate labels and attached to inside bottom] *MT. VERNON; 195*
PROVENANCE: Martha Parke Custis (Mrs. Thomas) Peter (1777–1854), granddaughter of Martha Washington; by descent to the Walter Peter family, Georgetown; acquired 1977
2006-3-10

CAT. 23

CAT. 24

CAT. 24. *Butter Dish and Cover*, c. 1778*

Made by Sèvres factory, Sèvres (1756–present); possibly gilded by Léopold Weydinger (active 1757–1806); porcelain with gilt decoration; diameter 8⁷⁄₁₆ inches (21.5 cm), height 3⅝ inches (9.2 cm)
MARK: [painted in blue on dish] *LL* [interlaced] / *g*
LABEL: [printed on label on dish] *64*; [handwritten on label inside cover] *Vn*
PROVENANCE: Martha Parke Custis (Mrs. Thomas) Peter (1777–1854), granddaughter of Martha Washington; by descent to the Walter Peter family, Georgetown; acquired 1980
PUBLISHED: Klapthor 1999, p. 26 (top)
2006-3-16a,b

CAT. 25. *Soup Plate*, c. 1785

Made by Dihl et Guérhard, Paris (1781–1828); porcelain with gilt decoration; diameter 9⅞ inches (25.1 cm)
MARKS: [stenciled in red] *MANUFre / de M.gr le Duc / d'angouleme / a Paris*
LABEL: [printed on label attached to rim] *250*
PROVENANCE: Martha Parke Custis (Mrs. Thomas) Peter (1777–1854), granddaughter of Martha Washington; by descent to the Walter Peter family, Georgetown; acquired 1980
2006-3-18

CAT. 26. *Plate*, c. 1778

Made by Sèvres factory, Sèvres (1756–present); gilded by Théodore (active 1765–c. 1780); porcelain with gilt decoration; diameter 9¹¹⁄₁₆ inches (24.6 cm)
MARKS: [painted in blue] Crown, *LL* [interlaced], and line of four dots

LABEL: [printed and attached to well] *282*
PROVENANCE: Martha Parke Custis (Mrs. Thomas) Peter (1777–1854), grand-daughter of Martha Washington; by descent to the Walter Peter family, George-town; acquired 1980
2006-3-19

CAT. 27. *Plate*, c. 1785
Made by Dihl et Guérhard, Paris (1781–1828); porcelain with gilt decoration; diameter 10 inches (25.4 cm)
MARKS: [stenciled in red] *MANUF^re / de M.^gr le Duc / d'angouleme / a Paris*
LABELS: [printed on separate labels and attached to front] *MT. VERNON*; *241*
PROVENANCE: Martha Parke Custis (Mrs. Thomas) Peter (1777–1854), grand-daughter of Martha Washington; by descent to the Walter Peter family, George-town; acquired 1980
2006-3-17

CAT. 28. *Cover for a Dessert Chiller*, c. 1777–80
Made by Locré and Russinger's factory, La Courtille, Paris (1772–1823); porcelain with gilt decoration; diameter 8⁷⁄₁₆ inches (21.5 cm)
LABEL: [printed and attached to flange] *133*
PROVENANCE: Martha Parke Custis (Mrs. Thomas) Peter (1777–1854), grand-daughter of Martha Washington; by descent to the Walter Peter family, George-town; acquired 1977
2006-3-13

CAT. 29. *Ice Pot*, c. 1778*
Made by Sèvres factory, Sèvres (1756–present); gilded by Capelle (active 1746–1800); porcelain with gilt decoration; height 2½ inches (6.4 cm)
MARKS: [painted in red] *LL* [interlaced]/[triangle]
PROVENANCE: The Custis Family; Allen Withers (b. 1807); his niece, Helen Withers, 1925; her cousin, Lucia Lufkin Smith Cote; an Indiana collector; sold at Sotheby Parke Bernet, New York, January 28, 1981, lot 192
2006-3-22

CAT. 30. *Teacup and Saucer*, c. 1778*
Made by Sèvres factory, Sèvres (1756–present); possibly gilded by Léopold Weydinger (active 1757–1806); porcelain with gilt decoration; height of cup 1⅞ inches (4.8 cm), diameter of cup 3¼ inches (8.3 cm), diameter of saucer 5⅛ inches (13 cm)
MARKS: [painted in blue on both] *LL* [interlaced], *g* [script]
PROVENANCE: Martha Parke Custis (Mrs. Thomas) Peter (1777–1854), granddaughter of Martha Washington; by descent to the Walter Peter family, Georgetown; acquired 1977
2006-3-11, 12

CAT. 29

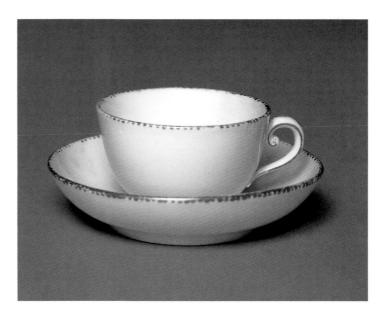

CAT. 30

English Porcelain

Traditionally attributed to a purchase made for or by the Washingtons in Philadelphia, objects in this pattern, produced by the Caughley factory in England between 1785 and 1795, may have been generally available in Philadelphia shops (cat. 31). Two pieces with a now-discounted Washington provenance were given to Mount Vernon by William Wilson Corcoran in 1879.

CAT. 31. *Dessert Plate*, c. 1785–95*

Made by Caughley factory, Shropshire (c. 1750–c. 1812); steatitic porcelain with enamel and gilt decoration; "Dresden Flowers" pattern; diameter 8⁷⁄₁₆ inches (21.5 cm)

LABEL: [written] *Nº 1 / General Washington*

PROVENANCE: Grinnell family of Newport and New York; Marjorie W. Hardy (1908–1992), Providence, Rhode Island; acquired 1972

PUBLISHED: Detweiler 1975, p. 10, no. 5; Klamkin, color pl. 6 (bottom left)

2006-3-4

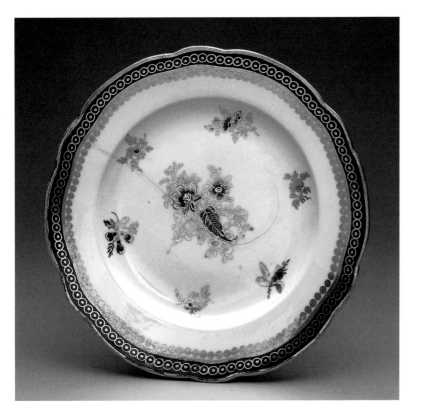

CAT. 31

JOHN ADAMS (1735–1826)
President, 1797–1801

John and Abigail Adams were the first couple to occupy the President's House, later known as the White House, in Washington, D.C. Presumably, tableware was taken from the Philadelphia residence to Washington in 1800, but little is known of what the Adams family used on the presidential table other than the cream-colored earthenware ("Queen's ware") that was purchased by the government and inventoried at the President's House in 1801. Remnants of Chinese, French, and English porcelain services acquired for family use are preserved at the Adams National Historic Site in Quincy, Massachusetts. Descendants asserted that John and Abigail Adams owned two services of Sèvres porcelain—one with polychrome bouquets and one with blue cornflower sprigs.[12]

THOMAS JEFFERSON (1743–1826)
President, 1801–9

The paucity of porcelains associated with Thomas Jefferson may be attributed to the burning of the President's House by the British in August 1814 and to debt-necessitated sales after his death. An inventory of government-purchased furnishings made at the end of President Jefferson's second term is too general for use in identifying extant objects. Jefferson returned from Paris in 1789 with eighty-six cases of French furnishings, including porcelains such as biscuit figures and sprig-decorated Sèvres tableware. Examples now at Monticello include Sevrès pieces dated 1786 and another French service thought to be by André and Company of about 1815. Sprig or cornflower patterns on table and tea porcelains were produced by many French factories and were extremely popular in the latter half of the eighteenth century.

JAMES MADISON (1751–1836)
President, 1809–17

French Porcelain

The burning of the President's House in August 1814 destroyed the material evidence of porcelains used during James and Dolley Madison's residence there, and the documentary evidence is too vague for convincing identification of official pieces. After the fire, the Madisons moved to rented quarters where, it is believed, they served entertainments with their own sets of French porcelain.

James Monroe sent an unidentified service of tea china from France to the Madisons in 1795 and later sold them a monogrammed service when he returned to Paris as ambassador in 1803. Inventories at Mrs. Madison's residence in Washington listed both coffee cups and teacups with matching saucers as well as a teapot, coffeepot, and bowl under "Gilt china marked M."[13] The cup now associated with the saucer is of later manufacture.

CAT. 32. *Saucer*, c. 1795*

Made by Blancheron's factory, Paris (1793–1802); decorated by Étienne Jean Louis Blancheron, Paris; porcelain with gilt decoration; diameter 5½ inches (14 cm)

MARK: [stenciled in red] *EB*

LABELS: [handwritten] *James Madison / (President) / cup owned / by Chas. A. Munn; 73 no il*

PROVENANCE: Colonel James Monroe (nephew of the president) and his wife, Elizabeth Mary Douglas; Mr. and Mrs. Theodore Douglas Robinson; sold at C. G. Sloan and Company, December 7, 1984, lot 2318

2006-3-45

CAT. 33. *Teacup*, c. 1815–25

Porcelain with gilt decoration; height 2¹⁵⁄₁₆ inches (7.5 cm)

PROVENANCE: Colonel James Monroe (nephew of the president) and his wife, Elizabeth Mary Douglas; Mr. and Mrs. Theodore Douglas Robinson; sold at C. G. Sloan and Company, December 7, 1984, lot 2318

2006-3-44

CAT. 32

Dinner and Dessert Service, 1806
French, made by Nast's factory, Paris (1783–1835);
porcelain with enamel and gilt decoration

On September 3, 1806, Fulwar Skipwith (1765–1839), U.S. Consul-General in Paris, wrote to James Madison: "Mr. [Jean Népomucême] Nast, the China Manufacturer, has at last executed the order which I gave him on my arrival here for your Table and Dessert sets of China."[14] The Madisons are believed to have used this service for official entertaining after the destruction of the President's House and furnishings in 1814, and much of the service was still in Mrs. Madison's possession at the time of her death in 1842. In 1837, four sauceboats and stands were inventoried among 190 pieces of the Nast service at her Washington home.[15] The Madisons' service, with its elaborately delineated borders of formal medallions and palms in black and white enamel on an orange ground, is characteristic of the Nast factory's production in the first decade of the nineteenth century.

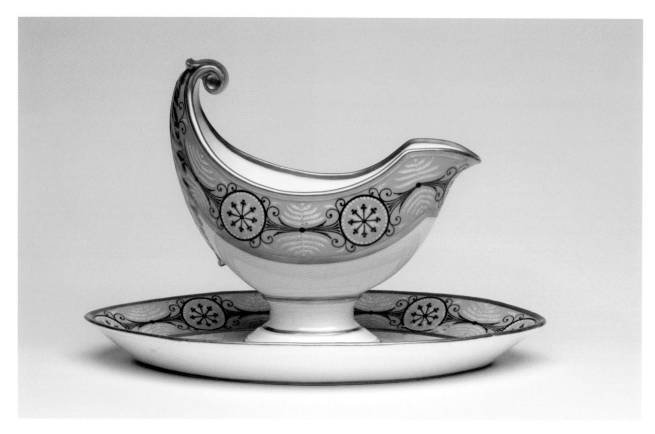

CAT. 34

CAT. 34. *Sauceboat and Stand**

Height of sauceboat 6½ inches (16.5 cm), length of sauceboat 6⅞ inches
(17.5 cm), length of stand 10⁵⁄₁₆ inches (26.1 cm)
MARKS: [painted in gold on sauceboat] *nast*; [stenciled in red on stand]
NAST / à / Paris
LABELS: [handwritten on oval paper label on stand] *Loan / Exhibit #9 / Property
of / J. S. Bradly Jr. / NY City*; [handwritten on octagonal paper label on stand] *21*
PROVENANCE: Causten and Cutts families (relatives of Dolley Madison);
Kunkel Sale (Philadelphia, Stan F. Henkels, 1899); J. S. Bradley; sold at Christie's
East, New York, October 24, 1989, lot 245
2006-3-47a,b

CAT. 35. *Plate**

Diameter 11⅜ inches (28.9 cm)
MARK: [stenciled in red] *NAST/à/Paris*
PROVENANCE: Causten and Cutts families (relatives of Dolley Madison);
Kunkel Sale (Philadelphia, Stan F. Henkels, 1899); J. S. Bradley; sold at Christie's
East, New York, October 24, 1989, lot 245
2006-3-46

CAT. 35

CAT. 36. *Plate*, c. 1800

Porcelain with gilt decoration; diameter 7¾ inches (19.7 cm)
LABELS: [typewritten] *This / Plate, Cup, and Saucer / belonged to the set used / in the White House / by / President Madison. / The Plate is one of two / recovered from the debris / after the British fired / the White House on August / the 24th. 1814. / The above statement is / made with good authority / at Washington, D.C. 1892. / By,* [signed] *A. M. Cooke.* [handwritten] *$625⁰⁰;* [handwritten] *DICKINS / 277 103 / 4*
PROVENANCE: A. M. Cooke, 1892; Admiral Francis W. Dickins (1844–1910), Washington, D.C.; Edith Pratt Dickins; Philip Pratt; Charles H. Cox; Charles H. Cox, Jr., Paoli, Pennsylvania; acquired 1972
2006-3-42

CAT. 37. *Teabowl*, c. 1785 *

Porcelain with enamel decoration; diameter 4⁵⁄₁₆ inches (10.9 cm)
LABELS: [handwritten] *DICKINS / 277432* [crossed out], *277342; Dolly* [sic] *Madison*
PROVENANCE: Admiral Francis W. Dickins (1844–1910), Washington, D.C.; Edith Pratt Dickins; Philip Pratt; Charles H. Cox; Charles H. Cox, Jr., Paoli, Pennsylvania; acquired 1972
PUBLISHED: Detweiler 1975, p. 17, no. 13
2006-3-43

CAT. 37

Chinese Export Porcelain

Long associated with James Madison, plates such as cat. 36 conceivably were among those in the first recorded sale of "decayed furniture" from the President's House in October 1810 or from a later sale. In December 1903, the journalist Abby Gunn Baker (d. 1923) wrote in *Munsey's Magazine* that the service had been destroyed in the fire of 1814, but that some pieces survived in a private collection. Mrs. Baker virtually quoted the text on old labels signed "A. M. Cooke" on the reverse of each of these plates. The 1890 directory for Washington, D.C., lists "Aaron M. Cooke, artistic repairs, 509 9th, N.W." The teabowl (cat. 37) is possibly related to two pieces of "Lowestoft" china in the catalogue for the Estate of Dolley Madison at Henkel's auction house in Philadelphia, 1899.[16]

JAMES MONROE (1758–1831)
President, 1817–25

State Dessert Service, 1817
French, made by Dagoty and Honoré, Paris (1816–1820);
porcelain with printed, enamel, and gilt decoration

The first surviving official (state) service is the dessert service for thirty persons ordered by President Monroe in 1817. The invoice that accompanied the 166 pieces upon delivery included four *corbeilles* (cat. 38), four *sucriers de table* (cat. 39), three dozen *assiettes creuses* (cat. 40), and seven dozen *assiettes plates* (cats. 41, 42).[17] As the first porcelain specifically commissioned for use in the White House, the design featured an elaborate decorative program of national symbolism created especially for the President's House. The amaranth border refers to a color and a flower believed never to fade, and therefore, to be immortal. The vignettes in the border represent strength, agriculture, commerce, art, and science. The Arms of the United States in the center of the plates, presented as an ascendant eagle, probably derive from American coinage of about 1810.

CAT. 38. *Footed Basket**
Diameter 9⁵⁄₁₆ inches (23.6 cm)
PROVENANCE: Sold at Christie's, New York, January 27, 1995, lot 98
2006-3-55

CAT. 39. *Sugar Bowl and Cover**
Height 6⅛ inches (15.6 cm), diameter 6 inches (15.2 cm)
PROVENANCE: Family of Eliza Monroe Hay (eldest daughter of President and Mrs. Monroe; 1786–1840); W. G. S. Baker, of Baltimore; his granddaughter, Mrs. Edward Wroth (1909–1980); acquired 1968
PUBLISHED: Detweiler 1975, p. 21, no. 16; Klapthor 1999, p. 45
2006-3-50a,b

CAT. 40. *Deep Dessert Plate*
Diameter 8⁹⁄₁₆ inches (21.7 cm)
MARKS: [stenciled in red] M.ᵗᵘʳᵉ de MADAME, / Duchesse d'Angoulême / P. L. Dagoty, E. Honoré / à Paris., [incised] V
PROVENANCE: William T. Crump (b. 1841); Stanley S. Wohl (1895–1978), Annapolis, Maryland; acquired 1970
2006-3-51

CAT. 38

CAT. 39

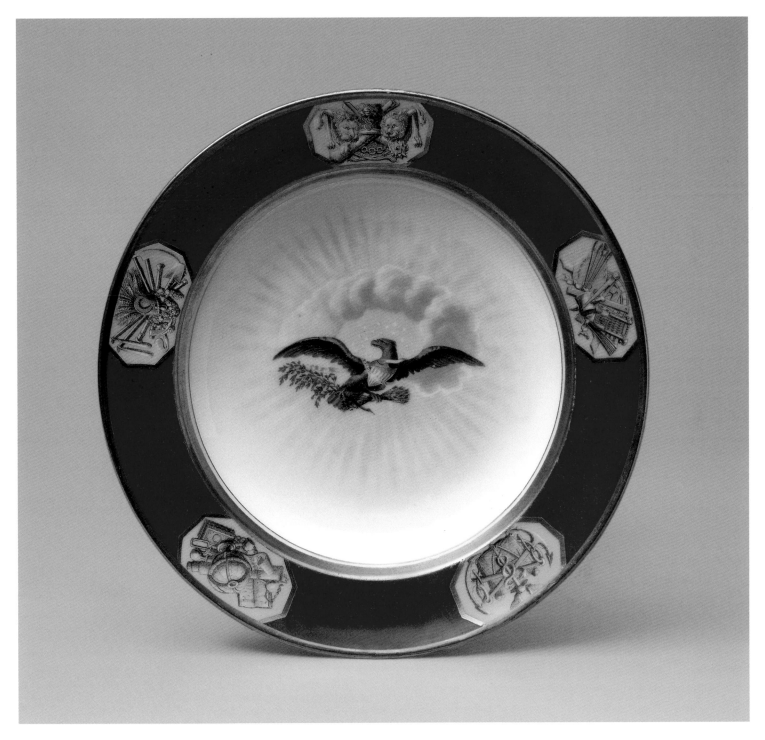

CAT. 42

CAT. 41. *Dessert Plate*

Diameter 8⅝ inches (21.9 cm)

MARKS: [stenciled in red] M.*ture* de *MADAME*, / *Duchesse d'Angoulême* / *P. L. Dagoty, E. Honoré* / *à Paris.*, [incised] *V*

PROVENANCE: White House sale, Duncanson Brothers, Washington, D.C., April 14, 1882; William T. Crump (b. 1841); William T. Crump, Jr.; John M. K. Davis, Hartford, Connecticut; Stanley S. Wohl (1895–1978), Annapolis, Maryland; acquired 1967

2006-3-49

CAT. 42. *Dessert Plate* *

Diameter 8⅝ inches (21.9 cm)

MARK: [incised] *V*

PROVENANCE: Jacob Kunkel (1822–1870) of Cactoctin Furnace Farms, Maryland; sold at Sotheby Parke Bernet, New York, November 19, 1980

2006-3-52

<div align="center">

Dessert Service, c. 1817–20

French, made by Dagoty and Honoré, Paris (1816–1820); porcelain with printed, enamel, and gilt decoration

</div>

Although undocumented, a French service with marbled blue borders and the Arms of the United States is visually related to the Monroe administration's state dessert service and bears the same manufacturer's mark, used only in the years 1816–20 (cats. 43–45). Provenance for surviving pieces of the Dagoty blue-bordered porcelain supports personal ownership by the Monroes. The service may have arrived in one or more of the six cases of unidentified goods, designated for Mrs. Monroe, that were shipped from Paris with the state dessert service and other furnishings for the President's House. The pattern has often been published as possibly President Andrew Jackson's state dessert china (see cats. 50–53). Two factors indicate that the Dagoty blue-bordered service was not the dessert set supplied to Jackson: First, forms not found on the detailed invoice for the Jackson porcelain from Lewis Veron exist in remnants of the marbled-blue-border service. Second, the Veron invoice specified "Greek form" cups, which probably would have had handles scrolling above the rim. Two cups matching the Dagoty blue-bordered service are of the simple "can" shape. These are at the Monroe Museum in Fredericksburg, Virginia, with a provenance of ownership by descendants of President and Mrs. Monroe. Pieces in at least two public collections share a common provenance through descendants of Daniel Webster, who identified the service as having belonged to the Monroes.[18]

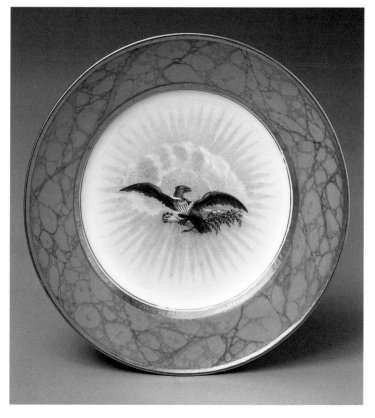

CAT. 45

CAT. 43. *Dessert Plate*

Diameter 8⅝ inches (21.9 cm)

MARKS: [stenciled in red] M.*ture* de *MADAME*, / *Duchesse d'Angoulême* / *P. L. Dagoty, E. Honoré* / *à Paris.*, [incised] *V*

PROVENANCE: Daniel Webster (1782–1852) and his second wife, Caroline LeRoy Webster; Mr. and Mrs. H. W. LeRoy; the Stradlings, New York; acquired 2005

2006-3-48

CAT. 44. *Dessert Plate*

Diameter 8⅝ inches (21.9 cm)

MARKS: [stenciled in red] M.*ture* de *MADAME*, / *Duchesse d'Angoulême* / *P. L. Dagoty, E. Honoré* / *à Paris.*, [incised] *V*

PROVENANCE: Daniel Webster (1782–1852) and his second wife, Caroline LeRoy Webster; Mr. and Mrs. H. W. LeRoy; by Webster family descent to a private collector; sold at Parke-Bernet Galleries, New York, October 25, 1969, lot 19 (a pair)

2006-3-56

CAT. 45. *Dessert Plate**

Diameter 8⁹⁄₁₆ inches (21.7 cm)
PROVENANCE: Daniel Webster (1782–1852) and his second wife, Caroline LeRoy Webster; Mr. and Mrs. H. W. LeRoy; Mrs. Emmett Hall of Ashfield, Massachusetts; Mrs. Gouverneur Morris Phelps; sold at Sotheby Parke Bernet, New York, January 29, 1976, lot 167
2006-3-57

CAT. 46

French Porcelain

In 1817, James Monroe sold his own "Table Set of French China, White and Gold" to the government for use in the President's House before the state porcelain arrived from Paris (cat. 46).[19] The shipment from Paris later that year included six cases designated for Mrs. Monroe as well as one case, known to have contained porcelain, for Mrs. Stephen Decatur, who subsequently sold her white-and-gold service to President Jackson. Mrs. Monroe's cases may also have contained white-and-gold porcelain to replace that sold to the government.

CAT. 46. *Coffee Pot and Cover*, c. 1810–15*

Porcelain with gilt decoration; height 10⅜ inches (26.4 cm)
PROVENANCE: Colonel James Monroe (nephew of the president) and his wife, Elizabeth Mary Douglas; Mr. and Mrs. Theodore Douglas Robinson; C. G. Sloan and Company, April 26, 1985
2006-3-54a,b

JOHN QUINCY ADAMS (1767–1848)
President, 1825–29

French Porcelain

John Quincy Adams purchased at least two Continental European porcelain services during his many years in the U.S. diplomatic service. Upon making a gift of fifty pieces to the Smithsonian Institution's Adams-Clement Collection, Miss Mary Louisa Adams Clement (1882–1950), a descendant of John Quincy and Louisa Catherine Adams, stated that a French set (including cats. 47, 48) was purchased at a private sale by John Quincy Adams during his service as American ambassador to Russia from 1809 to 1814.[20] The previous owner had been the Duke of Mondragone, minister to Russia from Naples. At least one surviving piece at the Smithsonian National Museum of American History is marked with the underglaze-blue crossed arrows used by Locré and Russinger's factory between 1773 and 1823. Other pieces bear an incised *N* (cat. 47) or *BL*. The service could be an assemblage of white ware from various factories painted by an independent decorator in Paris. The skillfully painted borders of foliate arabesques, antique cameo reserves, and gold medallions are rendered in the "Etruscan" style popularized by Henri

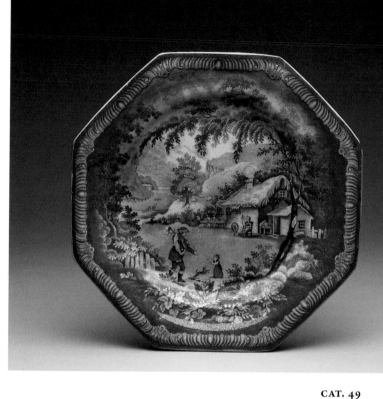

Salembier (1753–1820) in books of ornament, which were influential in creating the Louis XVI style.

CAT. 47. *Plate*, c. 1810*

Probably made by Locré and Russinger's factory, La Courtille, Paris (1772–1823); porcelain with printed, enamel, and gilt decoration; diameter 10⅜ inches (26.4 cm)

MARKS: [incised] *N / 7*

PROVENANCE: Descendants of President Adams; sold at Sotheby's, New York, January 31, 1985, lot 308

2006-3-59

CAT. 48. *Square Dish*, c. 1810

Probably made by Locré and Russinger's factory, La Courtille, Paris (1772–1823); porcelain with printed, enamel, and gilt decoration; width 8⅞ inches (22.5 cm)

PROVENANCE: Descendants of President Adams; sold at Sotheby's, New York, January 31, 1985, lot 308

2006-3-60

English Earthenware

White House Steward William Crump, who served during the administrations of Presidents Grant, Hayes, and Arthur, thought these earthenware pieces, manufactured by Brameld Company of Yorkshire, had been in the President's House during the Jefferson administration. Pearl ware with this transfer-printed pattern (known as "Returning Woodman" but which may have been called "Peasant" at the factory) was exported in quantity to Europe and America. The earliest documentary evidence for use of the pattern at Brameld was 1820, just six years before Jefferson died and many years after his presidency. The plate is more likely to have been from the "blue-printed dinner set" purchased in March 1825 for $35 at the store of A. B. Waller on Pennsylvania Avenue during the John Quincy Adams administration.[21] Another inexpensive dining service (not described) was purchased in May 1831 from Robinson Tyndale of Philadelphia during the Jackson administration.[22]

CAT. 49. *Octagonal Plate*, c. 1825*

Made by Brameld and Co., Swinton Old Pottery, Yorkshire (c. 1806–1842); white earthenware with printed underglaze blue decoration; diameter 9¾ inches (24.8 cm)

MARK: [impressed] *BRAMELD*

LABELS: [handwritten on octagonal labels] *DICKINS / 277102*; *Jefferson / $500*

PROVENANCE: Admiral Francis W. Dickins (1844–1910), Washington, D.C.; Edith Pratt Dickins; Philip Pratt; Charles H. Cox; Charles H. Cox, Jr., Paoli, Pennsylvania; acquired 1972

PUBLISHED: Detweiler 1975, p. 15, no. 10

2006-3-41

ANDREW JACKSON (1767–1845)
President, 1829–37

State Dessert Service, 1833

French; imported by Lewis Veron and Company (1826–c. 1840), Philadelphia; porcelain with enamel and gilt decoration

In 1833, Lewis Veron and Company of Philadelphia supplied "One Sett French China for Dinner with the american eagle" and a separate "Dessert Sett Blue & Gold, with Eagle," accompanied by detailed invoices, to the President's House.[23] The dinner service has not been identified, but research and the recent emergence of three serving pieces from the estate

CATS. 50, 51

CAT. 52 (TOP VIEW)

of Ben Perley Poore (1820–1887), whose book *Reminiscences* about his life in Washington, D.C., beginning in 1826, was published in 1886, has led to identification of the dessert set as one decorated with a bright blue border edged by gold vines and scrolls and centering three gold, transfer-printed eagles. Two complete dessert stands (cats. 50, 51) and two partial stands (cats. 52, 53) survive. Their forms correspond to the "6 Stands for Bonbons 3 stage" and "8 Tambours 3 stage" listed on Veron's invoice. The gilt transfer-printed version of the U.S. arms, a fierce eagle clutching the shield in its talons, had previously been printed on ephemera such as bank notes and ribbons commemorating the visit of the Marquis de Lafayette to the United States in 1824–25.[24]

CATS. 50, 51. *Two Stands for Bonbons*, 1833*

Height 13⅛ inches (33.3 cm), diameter 9⅛ inches (23.2 cm)
PROVENANCE: Ben Perley Poore (1820–1887), "Indian Hill," West Newbury, Massachusetts; Edward S. Mosley; sold at Northeast Auctions, Manchester, New Hampshire, February 23, 2007
2007-14-1, 2

CAT. 52. *Partial Stand for Bonbons*, c. 1833*

Height 4¾ inches (12.1 cm), diameter 9¾₆ inches (23.4 cm)
PROVENANCE: Michael Arpad, Washington, D.C.; acquired 1968
PUBLISHED: Klamkin, color pl. 11 (bottom); Margaret B. Klapthor, "Query: Presidential China," *Smithsonian Journal of History* 1 (1966), p. 73; Klapthor, p. 292 (top)
2006-3-254

CAT. 53. *Partial "Tambour" Dessert Stand*, 1833

Height 10½ inches (26.7 cm), diameter 7¹⁵⁄₁₆ inches (20.2 cm)
PROVENANCE: Ben Perley Poore (1820–1887), "Indian Hill," West Newbury, Massachusetts; Edward S. Mosley; sold at Northeast Auctions, Manchester, New Hampshire, February 23, 2007
2007-14-3

American Glassware

In 1829, Bakewell, Page and Bakewell of Pittsburgh, Pennsylvania, supplied a large service of "richest cut" glassware to the Jackson White House.[25] The service, engraved with grapevines and the arms of the United States, was supplemented later in the Jackson administration and again during the administrations of Martin Van Buren and James K. Polk. Wineglass coolers were purchased in 1837 and 1846 (cat. 54).

CAT. 54

CAT. 54. *Wineglass Cooler,* 1837 or 1846*

Possibly made by Bakewell, Page and Bakewell, Pittsburgh, Pennsylvania; colorless lead glass with engraved decoration; height 3⁹⁄₁₆ inches (9 cm), width 5⁵⁄₁₆ inches (13.5 cm)

PROVENANCE: Sold at Christie's, New York, January 21, 2006, lot 748

2006-3-61

JAMES K. POLK (1795–1849)
President, 1845–49

State Dinner and Dessert Service, 1846

French, made by Edouard D. Honoré, Champroux (1824–1855);
imported by Alexander T. Stewart and Company, New York (1823–1875);
porcelain with printed, enamel, and gilt decoration
MARKS: [printed in brown inside a scroll] *E D HONORÉ /*
Bould Poissonmière NO. 6 / à PARIS /
MANUFACTURE à Champroux Allier / N°. _____ / Prix _____

Shortly after his inauguration, President Polk asked his close friend William W. Corcoran (1798–1888) to supervise the furnishing of the White House. Corcoran undoubtedly was responsible for the purchase of a new state dinner and dessert service in New York. In March 1846, the "Merchant Prince," Alexander T. Stewart (1802–1876), who founded America's first department store the same year, shipped a new state dinner and dessert service to the White House.[26] Made in France by Edouard D. Honoré, successor to Dagoty and Honoré, the Polk state dinner service decoration includes, on the border of most pieces, a polychrome shield of the United States behind the national motto on a floating ribbon. The dessert service displays green borders with the shield in a reserve and large, botanically accurate flowers in the center of each piece. It included such elaborate forms as two "stands for confectionary" (cat. 59), "fruit stands" (cat. 60), and "common fruit stands" (cats. 61, 62).[27] By 1846, Honoré, who had a showroom in Paris and a factory in Champroux, was by far the leading producer of French tableware, much of which was specifically designed for the American market. Plates from the Polk dessert service without the molded rims and lobed cavettos of the original state service exist (cat. 66). They date to the mid-nineteenth century and were created (probably during the Taylor or Fillmore administrations) to supplement the original service.[28]

CAT. 55. *Platter*

Length 17⁷⁄₁₆ inches (44.3 cm)
ADDITIONAL MARKS: [incised] *16 / 2 /* [illegible]
PROVENANCE: Riley Browne; Stanley S. Wohl (1895–1978), Annapolis, Maryland; acquired 1969
PUBLISHED: Detweiler 1975, p. 36, no. 31
2006-3-69

CAT. 56. *Soup Plate*

Diameter 9⅝ inches (24.4 cm)
ADDITIONAL MARK: [incised] *1901*
PROVENANCE: Stanley S. Wohl (1895–1978), Annapolis, Maryland; acquired 1970
PUBLISHED: Detweiler 1975, p. 36, no. 30
2006-3-70

CAT. 57. *Dinner Plate*

Diameter 9⅜ inches (23.8 cm)
PROVENANCE: Alexander McKerichar (1831–1914), who was employed at the White House, 1855–75; Rebecca Esmer (1896–1981); acquired 1972
2006-3-71

CAT. 58. *Dinner Plate**

Diameter 9⅜ inches (23.8 cm)
ADDITIONAL MARK: [incised] *1901*
PROVENANCE: Weschler's Auctions, Washington, D.C., 1972, lot 838/2
2006-3-72

CAT. 59. *Dessert Stand*

Height 17½ inches (44.5 cm)
ADDITIONAL MARK: [incised on lowest plate] *1901*
PROVENANCE: Delaware collector; sold at Sotheby Parke Bernet, New York, January 31, 1979, lot 994
2006-3-75

CAT. 60. *Fruit Stand**

Height 9¾ inches (24.8 cm), diameter of bowl 11 inches (27.9 cm)
PROVENANCE: Michael Arpad, Washington, D.C.; acquired 1968
PUBLISHED: Detweiler 1975, p. 37, no. 34
2006-3-68

CATS. 61, 62. *Two Compotes**

Yellow Rose and Scabiosa; height 4½ inches (11.4 cm); diameter 9¹¹⁄₁₆ inches (24.6 cm)
ADDITIONAL MARK: [incised on cat. 61] *1901*
PROVENANCE: Michael Arpad, Washington, D.C.; acquired 1967
2006-3-66, 67

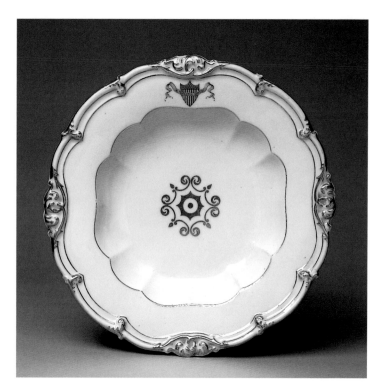

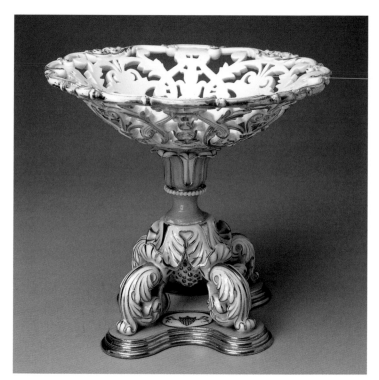

CAT. 58

CAT. 60

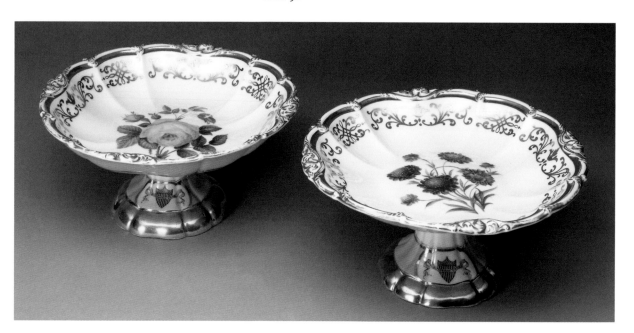

CATS. 61, 62

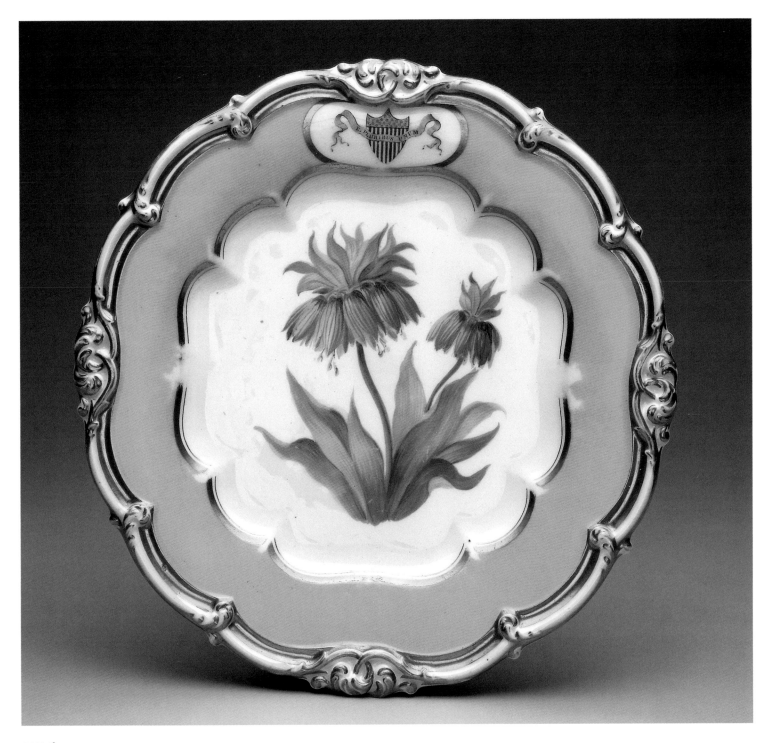

CAT. 63

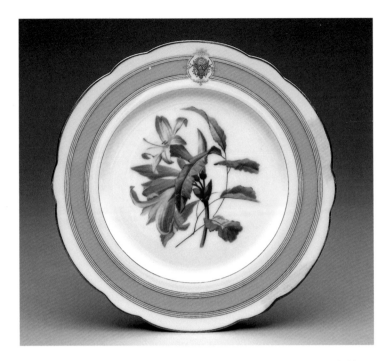

CAT. 98. *Dinner Plate*

Wild Rose; diameter 9⅜ inches (23.8 cm)
LABEL: [handwritten] *#14/2* [illegible] *8*
PROVENANCE: Butterfield and Butterfield, San Francisco, November 5, 1986, lot 1032
2006-3-136

CAT. 99. *Dinner Plate*

Wild Rose; diameter 9⅜ inches (23.8 cm)
PROVENANCE: Butterfield and Butterfield, San Francisco, November 5, 1986, lot 1032
2006-3-137

CAT. 100. *Side Plate*

Chrysanthemums; diameter 7⁹⁄₁₆ inches (19.2 cm)
MARKS: [printed in red] *HAVILAND & CIE / LIMOGES* [in an ellipse], *X.*, [impressed] *J*
LABEL: [handwritten] *DICKINS / 277130 / 108–123*
PROVENANCE: Admiral Francis W. Dickins (1844–1910), Washington, D.C.; Edith Pratt Dickins; Philip Pratt; Charles H. Cox; Charles H. Cox, Jr., Paoli, Pennsylvania; acquired 1972
2006-3-127

CAT. 101. *Side Plate*

Wild Rose; diameter 7⁹⁄₁₆ inches (19.2 cm)
MARKS: [printed in red] *HAVILAND & CIE / LIMOGES* [in an ellipse]
LABEL: [handwritten] *DICKINS / 277130 / 108–123*
PROVENANCE: Admiral Francis W. Dickins (1844–1910), Washington, D.C.; Edith Pratt Dickins; Philip Pratt; Charles H. Cox; Charles H. Cox, Jr., Paoli, Pennsylvania; acquired 1972
2006-3-129

CAT. 102. *Dessert Dish*

Chrysanthemums; diameter 7¼ inches (18.4 cm)
LABEL: [handwritten] *DICKINS / 277131 / 124*
PROVENANCE: Admiral Francis W. Dickins (1844–1910), Washington, D.C.; Edith Pratt Dickins; Philip Pratt; Charles H. Cox; Charles H. Cox, Jr., Paoli, Pennsylvania; acquired 1972
2006-3-128

CAT. 103. *Dinner Plate*, c. 1876–90

French, probably made by Haviland and Company, Limoges (1842–present); Tulip; porcelain with printed, enamel, and gilt decoration; diameter 8½ inches (21.6 cm)
MARKS: [stenciled in red] *Administration* [in script] / *"U.S. GRANT„*
LABEL: [typewritten in red] *#103 / Listed in / Old Book*
PROVENANCE: Mrs. Cross; Pennypacker's Auction, Shillington, Pennsylvania, 1967, lot 220
PUBLISHED: Klapthor 1999, p. 294
2006-3-124

White House Dinner Service, 1870

French, probably made by Haviland and Company, Limoges (1842–present); imported by J. W. Boteler and Brother, Washington, D.C. (1867–1881); porcelain with enamel and gilt decoration

White House employees recalled that the "rose band dinner set" was used by President Grant and his family for less formal occasions, especially breakfast.[34] It was delivered in January 1870, ahead of the state service, and also had been purchased from Haviland and Company of Limoges through J. W. Boteler and Brother of Washington, D.C. Several pieces of this service were sold at auction during the Arthur administration when they were thought to have been from the Pierce administration.

CAT. 104. *Pickle Dish**

Length 8⅞ inches (22.5 cm), width 5 inches (12.7 cm)
MARK: [impressed] *80*
LABELS: [handwritten] *Pierce / $500⁰⁰*; *DICKINS / 277107 / 9*
PROVENANCE: Admiral Francis W. Dickins (1844–1910), Washington, D.C.; Edith Pratt Dickins; Philip Pratt; Charles H. Cox; Charles H. Cox, Jr., Paoli, Pennsylvania; acquired 1972
2006-3-133

CAT. 105. *Cup and Saucer*

Height of cup 2³⁄₁₆ inches (5.6 cm), diameter of saucer 5 inches (12.7 cm)
LABEL: [handwritten] *Pierce / $500⁰⁰ (q)*
PROVENANCE: Admiral Francis W. Dickins (1844–1910), Washington, D.C.; Edith Pratt Dickins; Philip Pratt; Charles H. Cox; Charles H. Cox, Jr., Paoli, Pennsylvania; acquired 1972
2006-3-131, 132

French Porcelain

Purchased by or for the Grant family after the second order of state china, this service bears the mark of Haviland and Company and that of the Washington retailer J. W. Boteler and Brother. Grant descendants have given pieces to the White House and to the Grant Home in Galena, Illinois.

CAT. 106. *Dinner Plate*, c. 1875*

Made by Haviland and Company, Limoges (1842–present); porcelain with enamel and gilt decoration; diameter 9⁵⁄₁₆ inches (23.6 cm)
MARKS: [printed in red] *FABRIQUÉ PAR HAVILAND & Cᵒ/* [half circle] *POUR/ J.W. [BO]TELER / & BRO/ WASHINGT[ON, D.C.] / DÉCOR DÉPOSÉ/ REGISTERED*
LABELS: [printed] *DOROTHY S. WATERHOUSE / 313 Commonwealth Ave. / Boston, Mass o[?]5*; [handwritten] *Ulysses Grant. Plate from service / Bought for wedding of daughter Nellie / Grant given to me by grandson / of Gen. Grant (Haviland)*
PROVENANCE: Chapman Grant (b. 1887; son of Jesse Grant [1858–1945], youngest son of President Grant); Dorothy S. Waterhouse (1894–1982), Boston, 1965; sold at Sotheby Parke Bernet, New York, November 15, 1973, lot 770
PUBLISHED: Detweiler 1975, p. 55, no. 56
2006-3-134

Chinese Export Porcelain

Julia Dent Grant (1826–1902) ordered the service with a "USG" cypher and the popular "Rose Medallion" decoration in 1868 through Captain Daniel Ammen and Olyphant and Company in Hong Kong (cats. 107–12). Examples are preserved in at least five public collections.

President and Mrs. Grant probably acquired the so-called Fish Service, plates featuring enamel decoration with a prominent fish, during their Asian travels, undertaken in 1879 after President Grant left office (cat. 114)

CAT. 107. *Oval Platter*, 1868

Porcelain with enamel and gilt decoration; length 16¹⁄₁₆ inches (40.8 cm), depth 13³⁄₁₆ inches (33.5 cm)

PROVENANCE: Jesse (1858–1945) and Elizabeth Grant (the youngest son and daughter-in-law of President Grant); to their grandson, Ulysses S. Grant V (b. 1920), Escondido, California; sold at Sotheby's, New York, January 18, 2001, lot 163

2006-3-118

CAT. 108. *Soup Tureen Stand*, 1868

Porcelain with enamel and gilt decoration; length 13⅝ inches (34.6 cm), depth 11½ inches (29.2 cm)

PROVENANCE: Jesse (1858–1945) and Elizabeth Grant (the youngest son and daughter-in-law of President Grant); to their grandson, Ulysses S. Grant V (b. 1920), Escondido, California; sold at Sotheby's, New York, January 18, 2001, lot 163

2006-3-119

CAT. 109. *Plate*, 1868*

Porcelain with enamel and gilt decoration; diameter 10 inches (25.4 cm)

PROVENANCE: Jesse (1858–1945) and Elizabeth Grant (the youngest son and daughter-in-law of President Grant); to their grandson, Ulysses S. Grant V (b. 1920), Escondido, California; sold at Sotheby's, New York, January 18, 2001, lot 163

2006-3-122

CAT. 110. *Plate*, 1868

Porcelain with enamel and gilt decoration; diameter 9¾ inches (24.8 cm)

PROVENANCE: Sold at Christie's, January 23, 2002, lot 158

2006-3-117

CATS. 111, 112. *Two Cups and Saucers*, 1868

Porcelain with enamel and gilt decoration; height of cups 2⁷⁄₁₆ (6.2 cm) and 2⅜ inches (6 cm), diameter of saucers 5⅝ (14.3 cm) and 5⁹⁄₁₆ inches (14.2 cm)

CAT. 109

PROVENANCE: Jesse (1858–1945) and Elizabeth Grant (the youngest son and daughter-in-law of President Grant); to their grandson, Ulysses S. Grant V (b. 1920), Escondido, California; sold at Sotheby's, New York, January 18, 2001, lot 162

2006-3-112–115

CAT. 113. *Teapot and Cover with Original Case*, c. 1868–79

Porcelain with enamel and gilt decoration (teapot); rattan, silk, and brass (case); height of teapot (without handles) 6⅜ inches (16.2 cm), height of rattan case (without handles) 8⁹⁄₁₆ inches (21.7 cm)

PROVENANCE: Jesse (1858–1945) and Elizabeth Grant (the youngest son and daughter-in-law of President Grant); to their grandson, Ulysses S. Grant V (b. 1920), Escondido, California; sold at Sotheby's, New York, January 18, 2001, lot 162

2006-3-116a–c

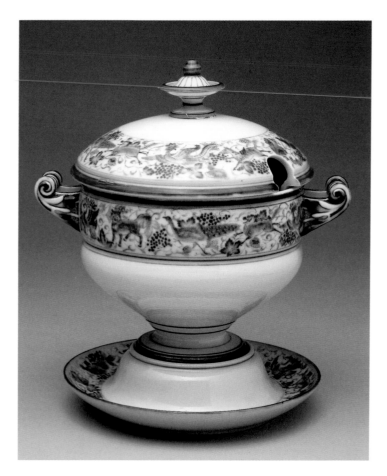

CAT. 114. *Plate*, c. 1879

Porcelain with enamel and gilt decoration; diameter 9¾ inches (24.8 cm)
PROVENANCE: Christie's, New York, January 21, 2006, lot 746
2006-3-123

Japanese Export Porcelain Dessert Service, 1879

Made by Seiji Kaisha, Arita (1879–1889)
Porcelain with underglaze blue decoration

Western forms characterize the "Mikado" dinner service manufactured by Seiji Kaisha (Pure Water Company) of Arita, Japan. By family tradition, the service was presented to the Grants by the Meiji emperor during their six-week visit to Japan in 1879.

CAT. 115. *Sauce Tureen Cover and Stand*, 1879*

Height 7½ inches (19.1 cm), width of tureen (with handles) 6⅞ inches (17.5 cm)
MARKS: [painted in underglaze blue on stand] *Seiji Kaisha kinsei* [in Japanese characters]
PROVENANCE: Jesse (1858–1945) and Elizabeth Grant (the youngest son and daughter-in-law of President Grant); to their grandson, Ulysses S. Grant V (b. 1920), Escondido, California; sold at Sotheby's, New York, January 18, 2001, lot 164
2006-3-120a–c

RUTHERFORD B. HAYES (1822–1893)
President, 1877–81

State Dinner and Dessert Service, 1879–80 and 1886

French; designed by Theodore Russell Davis (American, 1840–1894);
made by Haviland and Company, Limoges (1842–present); porcelain
with chromolithograph, enamel, and gilt decoration

Bearing elaborate depictions of American flora and fauna inspired by the work of contemporary French ceramists, the state service commissioned from Haviland and Company during the Hayes administration comprised 562 pieces for nine courses with 130 distinct decorations (cats. 116–25).[35] The creator of the images, artist Theodore R. Davis, granted to Haviland the right to duplicate many pieces for exhibition and sale to the public. White House china in the initial shipments of June and December 1880 is distinguished (on the reverse, among numerous other marks) by a cipher of Davis's initials with the date "1879." Pieces made for sale to the public and those ordered during the Grover Cleveland administration in 1886 (cats. 126–39) lack the cipher and have patent numbers printed in blue on the reverse.

CAT. 116. *Soup Plate*, 1879*

"The Blue Crab"; diameter 9 inches (22.9 cm)
MARKS: [printed in red] *FABRIQUÉ PAR / HAVILAND & Cᵒ / d'après les dessins / DE /* [printed in black] *Theo. R Davis* [script]; [printed in green] *H & Cᵒ* [double underline]; [printed in brown] *LIMOGES / HAVILAND & Cᵒ / 1879*; [printed in red and blue] *TRD*
PROVENANCE: Christie's East, New York, May 16, 1990, lot 94
2006-3-164

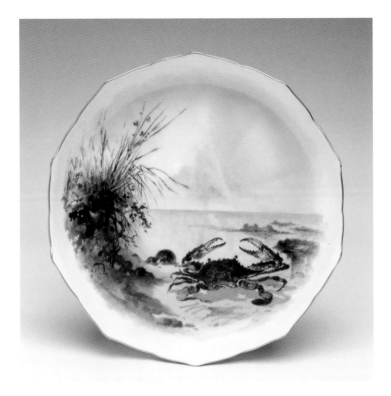

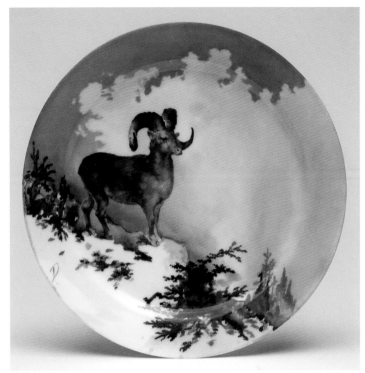

CAT. 116

CAT. 119

CAT. 117. *Soup Plate*, 1879

"Southward Flight of Ducks"; diameter 8¹⁵⁄₁₆ inches (22.7 cm)

MARKS: [printed in red] *FABRIQUÉ PAR / HAVILAND & Cᵒ / d'après les dessins / DE /* [printed in black] *Theo. R Davis* [script]; [printed in green] *H & Cᵒ* [double underline]; [printed in brown] *LIMOGES / HAVILAND & Cᵒ / 1879*; [printed in red and blue] *TRD*

LABEL: [handwritten] *DICKINS / 277133 /131*

PROVENANCE: Admiral Francis W. Dickins (1844–1910), Washington, D.C.; Edith Pratt Dickins; Philip Pratt; Charles H. Cox; Charles H. Cox, Jr., Paoli, Pennsylvania; acquired 1972

2006-3-154

CAT. 118. *Soup Plate*, 1879

"American Soup of the XV Century"; diameter 9 inches (22.9 cm)

MARKS: [printed in red] *FABRIQUÉ PAR / HAVILAND & Cᵒ / d'après les dessins / DE /* [printed in black] *Theo. R Davis* [script]; [printed in green] *H & Cᵒ* [double underline]; [printed in brown] *LIMOGES / HAVILAND & Cᵒ / 1879*; [printed in red and blue] *TRD*

PROVENANCE: Marjorie W. Hardy (1908–1992), Providence, Rhode Island; acquired 1972

PUBLISHED: Detweiler 1975, pp. 56, 58 no. 61

2006-3-156

CAT. 119. *Dinner Plate*, 1879*

"Big-Horn (Rocky Mountain Sheep)"; diameter 10⅛ inches (25.7 cm)

MARKS: [printed in red] *FABRIQUÉ PAR / HAVILAND & Cᵒ / d'après les dessins / DE /* [printed in black] *Theo. R Davis* [script]; [printed in green] *H & Cᵒ* [double underline]; [printed in brown] *LIMOGES / HAVILAND & Cᵒ / 1879*; [printed in red and blue] *TRD*

PROVENANCE: Sold at Sotheby's, New York, January 25, 1989, lot 8

2006-3-163

CAT. 120. *Ice Cream Platter*, 1880

Length 19 inches (48.2 cm), height 2¾ inches (7 cm), width 12 inches (30.5 cm)

MARKS: [printed in red] *FABRIQUÉ PAR / HAVILAND & Cᵒ / d'après les dessins / DE /* [printed in black] *Theo. R Davis* [script] / [printed in blue] *DESIGN PATENTED / AUGUST 10ᵗʰ 1880 /* [printed in green] *H & Cᵒ* [double underline] / [impressed] *B18*

LABELS: [handwritten] *715; 3423-7 / 8306*

CAT. 121

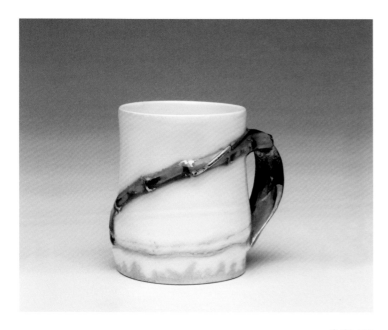

PROVENANCE: Thomas and Bunty Armstrong, New York; sold at Northeast Auctions, Manchester, New Hampshire, April 1, 2005, lot 600
2006-3-143

CAT. 121. *Ice Cream Plate*, 1880*

Width 7⅜ inches (18.7 cm)
MARKS: [printed in red] *FABRIQUÉ PAR / HAVILAND & Cᵒ / d'après les dessins / DE* / [printed in black] *Theo. R Davis* [script] / [printed in green] *H & Cᵒ* [double underline] / [printed in brown] *LIMOGES / HAVILAND & Cᵒ / 1879*; [printed in red and blue] *TRD*
LABEL: [handwritten] *DICKINS / 277138 / 137*
PROVENANCE: Admiral Francis W. Dickins (1844–1910), Washington, D.C.; Edith Pratt Dickins; Philip Pratt; Charles H. Cox; Charles H. Cox, Jr., Paoli, Pennsylvania; acquired 1972
2006-3-155

CAT. 122. *Ice Cream Plate*, 1880

Width 7⅜ inches (18.7 cm)
MARKS: [printed in red] *FABRIQUÉ PAR / HAVILAND & Cᵒ / d'après les dessins / DE* / [printed in black] *Theo. R Davis* [script] / [printed in green] *H & Cᵒ* [double underline] / [printed in brown] *LIMOGES / HAVILAND & Cᵒ / 1879*; [printed in red and blue] *TRD*
PROVENANCE: Sold at Sotheby Parke Bernet, New York, June 22, 1979, lot 620
2006-3-158

CAT. 123. *After-Dinner Coffee Cup*, 1879*

Height 2⁷⁄₁₆ inches (6.3 cm), width (with handle) 3 inches (7.6 cm)
MARKS: [printed in red] *FABRIQUÉ PAR / HAVILAND & Cᵒ / d'après les dessins / DE* / [printed in black] *Theo. R Davis* [script] / [printed in green] *H & Cᵒ* / [printed in brown] *LIMOGES / HAVILAND & Cᵒ / 1879* / [printed in red and blue] *TRD*
LABEL: [handwritten] *DICKINS / 277143 / 142*
PROVENANCE: Admiral Francis W. Dickins (1844–1910), Washington, D.C.; Edith Pratt Dickins; Philip Pratt; Charles H. Cox; Charles H. Cox, Jr., Paoli, Pennsylvania; acquired 1972
PUBLISHED: Detweiler 1975, p. 59 no. 59
2006-3-153

CATS. 124, 125. *Two After-Coffee Plates (Cigars, Cheese, and Crackers)*, 1880*

Diameter 9 inches (22.9 cm)
MARKS: [printed in red] *FABRIQUÉ PAR / HAVILAND & Cᵒ / d'après les dessins / DE* / [printed in black] *Theo. R Davis* [script] / [printed in green] *H & Cᵒ* / [printed in brown] *LIMOGES / HAVILAND & Cᵒ / 1879* / [printed in red and blue] *TRD*
PROVENANCE: Sold at Sotheby Parke Bernet, New York, June 22, 1979, lot 621
2006-3-159, 160

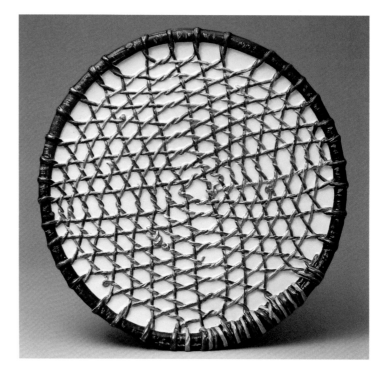

CAT. 125

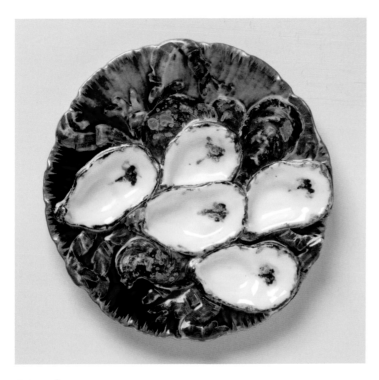

CAT. 126

CAT. 126. *Oyster Plate*, c. 1880–87*

Diameter 8¾ inches (22.2 cm)

MARKS: [printed in red] *FABRIQUÉ PAR / HAVILAND & Cº / d'après les dessins / DE /* [printed in black] *Theo. R Davis* [script] / [printed in green] *H & Cº* [double underline]; [printed in blue] *DESIGN PATENTED / AUGUST 10ᵗʰ 1880*

PROVENANCE: Stanley S. Wohl (1895–1978), Annapolis, Maryland; acquired 1967

2006-3-144

CAT. 127. *Soup Plate*, c. 1880–87

"Mountain Laurel"; diameter 9 inches (22.9 cm)

MARKS: [printed in red] *FABRIQUÉ PAR / HAVILAND & Cº / d'après les dessins / DE /* [printed in black] *Theo. R Davis* [script] / [printed in green] *H & Cº* [double underline]; [printed in blue] *DESIGN PATENTED / AUGUST 10ᵗʰ 1880 / Nº 11933*

PROVENANCE: Stanley S. Wohl (1895–1978), Annapolis, Maryland; acquired 1967

2006-3-146

CAT. 128. *Fish Service Platter*, c. 1880–87*

"The Shad"; length 24½ inches (62.2 cm), width 9 inches (22.9 cm)

MARKS: [printed in red] *FABRIQUÉ PAR / HAVILAND & Cº / d'après les*

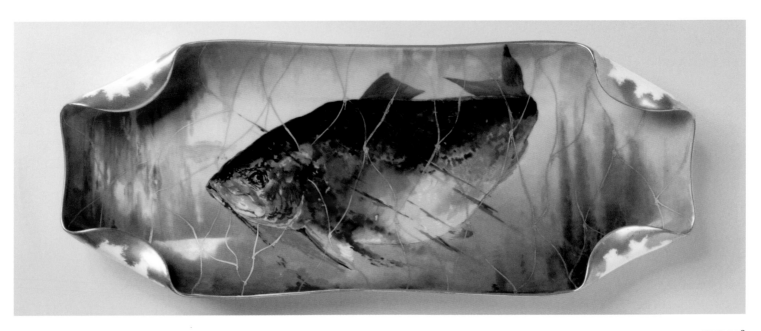

CAT. 128

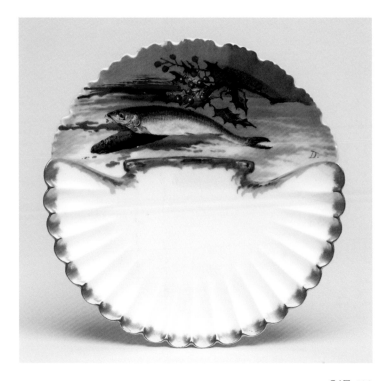

H & C° [double underline]; [printed in blue] DESIGN PATENTED / AUGUST 10th 1880 / N° 11935
PROVENANCE: Sold at Sotheby Parke Bernet, New York, November 19, 1980, lot 439
2006-3-162

CAT. 131. *Dinner Service Platter*, c. 1882*

"Wild Turkey"; length 19⅞ inches (50.5 cm)
MARKS: [printed in red] *FABRIQUÉ PAR / HAVILAND & C° / d'après les dessins / DE* / [printed in black] *Theo. R Davis* [script] / [printed in green] *H & C°* [double underline]; [printed in blue] *DESIGN PATENTED / AUGUST 10th 1880 / N° 11936* / [impressed] *B19*
PROVENANCE: John A. Rice, New York, 1882; Mrs. C. B. Wheeler, Kansas City; acquired 1977
2006-3-157

CAT. 132. *Dinner Plate*, c. 1880–87

"The Cranes' Walk 'Round"; diameter 10⅛ inches (25.7 cm)
MARKS: [printed in red] *FABRIQUÉ PAR / HAVILAND & C° / d'après les dessins / DE* / [printed in black] *Theo. R Davis* [script] / [printed in green] *H & C°* [double underline]; [printed in blue] *DESIGN PATENTED / AUGUST 10th 1880 / N° 11936*
PROVENANCE: Sold at Sotheby Parke Bernet, New York, November 19, 1980, lot 437
2006-3-161

CAT. 133. *Game Platter*, c. 1880–87*

"On Chesapeake Bay"; length 18⅝ inches (47.3 cm)
MARKS: [printed in red] *FABRIQUÉ PAR / HAVILAND & C° / d'après les dessins / DE* / [printed in black] *Theo. R Davis* [script] / [printed in green] *H & C°* [double underline]; [printed in blue] *DESIGN PATENTED / AUGUST 10th 1880 / N° 11932* / [impressed] *B18*
PROVENANCE: Stanley S. Wohl (1895–1978), Annapolis, Maryland; acquired 1969
2006-3-149

CAT. 134. *Game Plate*, c. 1880–87*

"California Quail"; diameter 9 inches (22.9 cm)
MARKS: [printed in red] *FABRIQUÉ PAR / HAVILAND & C° / d'après les dessins / DE* / [printed in black] *Theo. R Davis* [script] / [printed in green] *H & C°* [double underline]; [printed in blue] *DESIGN PATENTED / AUGUST 10th 1880 / N° 11932*
LABEL: [typewritten] *THE WHITE HOUSE PORCELAIN SERVICE / CALIFORNIA QUAIL*
PROVENANCE: William T. Crump (b. 1841); Stanley S. Wohl (1895–1978), Annapolis, Maryland; acquired 1967
2006-3-145

dessins / DE / [printed in black] *Theo. R Davis* [script] / [printed in green] *H & C°* [double underline]; [printed in blue] *DESIGN PATENTED / AUGUST 10th 1880 / N° 11935* / [impressed] *B24*
PROVENANCE: The Philadelphia Antique Shop; acquired 1971
2006-3-151

CAT. 129. *Fish Plate*, c. 1880–87

"Pompano"; diameter 8¼ inches (21 cm)
MARKS: [printed in red] *FABRIQUÉ PAR / HAVILAND & C° / d'après les dessins / DE* / [printed in black] *Theo. R Davis* [script] / [printed in green] *H & C°* [double underline]; [printed in blue] *DESIGN PATENTED / AUGUST 10th 1880 / N° 11935*
PROVENANCE: The Philadelphia Antique Shop; acquired 1971
2006-3-152

CAT. 130. *Fish Plate*, c. 1880–87*

"Smelt"; diameter 8⅜ inches (21.3 cm)
MARKS: [printed in red] *FABRIQUÉ PAR / HAVILAND & C° / d'après les dessins / DE* / [printed in black] *Theo. R Davis* [script] / [printed in green]

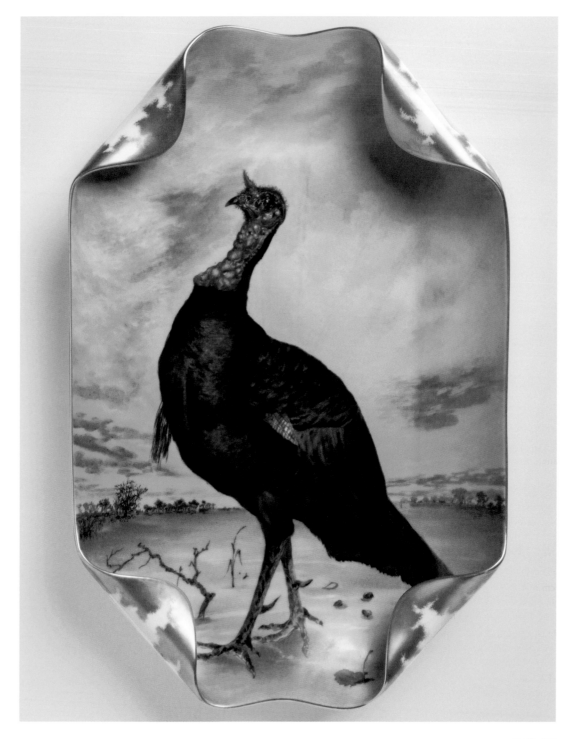

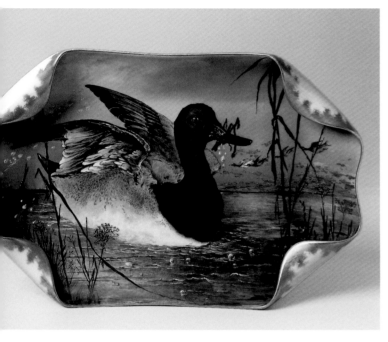

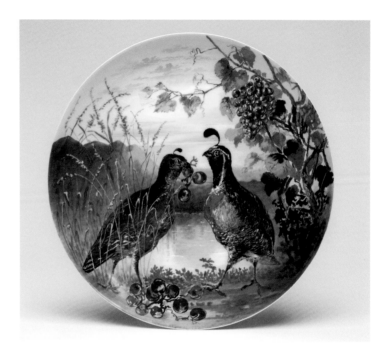

CAT. 135. *Game Plate*, c. 1880–87

"The Canvas-Back Duck"; diameter 9 inches (22.9 cm)

MARKS: [printed in red] *FABRIQUÉ PAR / HAVILAND & Cᵒ / d'après les dessins / DE /* [printed in black] *Theo. R Davis* [script] / [printed in green] *H & Cᵒ* [double underline]; [printed in blue] *DESIGN PATENTED / AUGUST 10ᵗʰ 1880 / Nᵒ 11932*

PROVENANCE: Stanley S. Wohl (1895–1978), Annapolis, Maryland; acquired 1970

2006-3-150

CAT. 136. *Fruit Plate*, c. 1883–87*

Imported by Camerden and Forster, New York (1883–1904); "The Studio"; length 9½ inches (24.1 cm), depth 8 inches (20.3 cm)

MARKS: [printed in red] *FABRIQUÉ PAR / HAVILAND & Cᵒ / d'après les dessins / DE /* [printed in black] *Theo. R Davis* [script] / [printed in green] *H & Cᵒ* [double underline]; [printed in blue] *DESIGN PATENTED / AUGUST 10ᵗʰ 1880 / Nᵒ 11934 /* [printed in brown] *HAVILAND & Cᵒ / FOR / CAMERDEN & FORSTER / NEW YORK*

PROVENANCE: Michael Arpad, Washington, D.C.; acquired 1967

2006-3-147

CAT. 137. *Fruit Plate*, c. 1883–87

Imported by Camerden and Forster, New York (1883–1904); "Maple Sugar"; length 9¼ inches (23.5 cm), depth 8 inches (20.3 cm)
MARKS: Same as cat. 136
PROVENANCE: Michael Arpad, Washington, D.C.; acquired 1967
2006-3-148

CAT. 138. *After-Dinner Coffee Cup and Saucer*, c. 1880–87

Height of cup 2⁷⁄₁₆ inches (6.3 cm), width (with handle) 3 inches (7.6 cm), diameter of saucer 4¾ inches (12.1 cm)
MARKS: [stamped in green on cup] *H & Cº.*; [stamped in green on saucer] *H & Cº.* [double underline]
LABEL: [handwritten in green ink on cup] *715*
PROVENANCE: Thomas and Bunty Armstrong, New York; sold at Northeast Auctions, Manchester, New Hampshire, April 1, 2005, lot 602
2006-3-139, 140

CAT. 139. *After-Dinner Coffee Cup and Saucer*, c. 1880–87

Height of cup 2½ inches (6.3 cm), width (with handle) 3 inches (7.6 cm), diameter of saucer 4¾ inches (12.1 cm)
MARKS: Same as cat. 138
PROVENANCE: Same as cat. 138
2006-3-141, 142

GROVER CLEVELAND (1837–1908)
President, 1885–89 and 1893–97

Presentation Tea Service, c. 1895

Russian, made by the M. S. Kuznetsov Partnership, Dulevo (established 1889); porcelain with enamel and gilt decoration
MARKS: [printed in gold] [crown surmounting double-headed eagle holding shield] *М. С. КУЗНЕЦОВА* [in a scroll below shield] / *ВЪАУПСВБ* [within scroll], [painted in black] *23.*
PROVENANCE: Anita Pawluk, New Jersey, sold William Doyle Galleries, March 26, 2002, lot 182

Students at the Demidoff vocational school in Russia presented a twelve-piece porcelain tea service to First Lady Frances Folsom Cleveland (1864–1947) in gratitude for her efforts to alleviate the Great Famine of 1891–92. The service, decorated in deep rose with gold and blue geometric bands, comprises a teapot, covered creamer, covered sugar

CAT. 140

bowl, waste bowl, and eight cups and saucers. It was manufactured and marked by the M. S. Kuznetsov Partnership.

CAT. 140. *Teapot**
Height 5 inches (12.7 cm)
2006-3-168a,b

CAT. 141. *Covered Creamer*
Height 3¾ inches (9.5 cm)
2006-3-169a,b

CAT. 142. *Covered Sugar*
Height 4⁵⁄₁₆ inches (11 cm)
2006-3-170a,b

CAT. 143. *Waste Bowl*
Diameter 6⁵⁄₁₆ inches (16 cm)
2006-3-171

CAT. 144. *Two Sets of Cups and Saucers*
Height of cups 3⁵⁄₁₆ inches (8.4 cm), diameter of saucers 5½ inches (14 cm)
2006-3-172–75

BENJAMIN HARRISON (1833–1901)
President, 1889–93

State Dinner, Dessert, and Breakfast Service, 1891
French; designed by Caroline Lavinia Scott Harrison (1832–1892) with Paul Putzki (1858–1936); made by Tressemanes and Vogt, Limoges (1891–c. 1919); imported by M. W. Beveridge, Washington, D.C. (1870–1900); porcelain with printed, enamel, and gilt decoration
MARKS: [printed in green] *T & V* [in rectangle] *FRANCE* / [printed in gold] *T & V* [in a bell] / *FRANCE* / *HARRISON 1892*

Caroline Scott Harrison (1832–1892), an avid china painter, designed a new dining service of soup, dinner, breakfast, and tea plates with references to the Lincoln state service in the overall shape and in the inclusion of the Arms of the United States at the center. American flora were represented by the corn and goldenrod traced in gold on the border.

Her designs were given in 1891 to the Washington, D.C., retail firm M. W. Beveridge, which secured sample plates from several factories in Limoges. Mrs. Harrison chose the plate made by Tressemanes and Vogt, a Limoges factory directed by the retail firm Vogt and Dose in New York. The original order of plates was received in December 1891; two years later, five dozen after-dinner coffee cups were added. Reorders arrived in 1898, during the McKinley administration, and in 1908, during the Theodore Roosevelt administration. The 1908 supplements were supplied by Dulin and Martin Company, successors (after 1899) to Beveridge. The plates reordered by the White House from Beveridge and Dulin and Martin and those made for sale to the general public (see cats. 148–53) all bear marks differing slightly from those found on the pieces from the 1891 order (including cats. 145–47).[36]

CAT. 145. *Soup Plate*, 1891
Diameter 9 inches (22.9 cm)
ADDITIONAL MARKS: [printed in gold] *DÉCORÉ POUR / M.W. BEVERIDGE / WASHINGTON, D.C.*
PROVENANCE: Sold at Sotheby Parke Bernet, New York, November 19, 1980, lot 443
2006-3-190

CAT. 146. *Dinner Plate*, 1891*
Diameter 9½ inches (24.1 cm)
ADDITIONAL MARKS: [printed in gold] *DÉCORÉ POUR / M.W. BEVERIDGE / WASHINGTON, D.C.*
LABEL: [handwritten] *DICKINS / 27140 / 140*
PROVENANCE: Admiral Francis W. Dickins (1844–1910), Washington, D.C.; Edith Pratt Dickins; Philip Pratt; Charles H. Cox; Charles H. Cox, Jr., Paoli, Pennsylvania; acquired 1972
2006-3-185

CAT 147. *Breakfast Plate*, 1891*
Diameter 8½ inches (21.6 cm)
ADDITIONAL MARKS: [printed in gold] *DÉCORÉ POUR / M.W. BEVERIDGE / WASHINGTON, D.C.*
LABEL: [remnants of paper label, possibly same as cat. 146]
PROVENANCE: Admiral Francis W. Dickins (1844–1910), Washington, D.C.; Edith Pratt Dickins; Philip Pratt; Charles H. Cox; Charles H. Cox, Jr., Paoli, Pennsylvania; acquired 1972
2006-3-186

CAT. 146

CAT. 148. *Dessert Plate*, 1892–99

Diameter 8½ inches (21.6 cm)
ADDITIONAL MARKS: [printed in gold] *DÉCORÉ POUR / M.W. BEVERIDGE / WASHINGTON, D.C.*
PROVENANCE: Mrs. Virginia Beecher-Smith; sold at Parke-Bernet Galleries, May 9, 1967, lot 30
2006-3-181

CAT. 149. *Tea Plate*, 1892–99

Diameter 7⅜ inches (18.7 cm)
ADDITIONAL MARKS: [printed in gold] *DÉCORÉ POUR / M.W. BEVERIDGE / WASHINGTON, D.C.*
PROVENANCE: Virginia Beecher-Smith of Binghamton, New York; sold at Parke-Bernet Galleries, May 9, 1967, lot 29
2006-3-180

CAT. 150. *Tea Plate*, 1892–99

Diameter 7⅜ inches (18.7 cm)
ADDITIONAL MARKS: [printed in gold] *DÉCORÉ POUR / M.W. BEVERIDGE / WASHINGTON, D.C.*
PROVENANCE: Butterfield and Butterfield, San Francisco, November 5, 1986, lot 1035
2006-3-191

CAT. 151. *Dinner Plate*, after 1899

Diameter 9½ inches (24.1 cm)
ADDITIONAL MARKS: [printed in gold] *POUR / Dulin, Martin Co. / WASHINGTON*
PROVENANCE: South Carolina collector; sold at Sotheby Parke Bernet, New York, January 29, 1976, lot 171
2006-3-187

CAT. 152. *Breakfast Plate*, 1892–99

Diameter 8½ inches (21.6 cm)
ADDITIONAL MARKS: [printed in gold] *DÉCORÉ POUR / M.W. BEVERIDGE / WASHINGTON, D.C.*
PROVENANCE: Mrs. Virginia Beecher-Smith, Binghamton, New York; sold at Parke-Bernet Galleries, May 9, 1967, lot 32
2006-3-182

CAT. 153. *Teacup and Saucer*, c. 1892

Porcelain with printed, enamel, and gilt decoration; height of cup 2⅛ inches (5.4 cm), diameter of cup 3½ inches (8.9 cm), diameter of saucer 5½ inches (14 cm)
MARKS: [printed in green on cup] *T & V* [in a rectangle] */ LIMOGES / FRANCE*; saucer same as cat. 146
PROVENANCE: Dorothy S. Waterhouse (1894–1982), Boston; acquired 1976
2006-3-188, 189

WILLIAM McKINLEY (1843–1901)
President, 1897–1901

Knowles, Taylor and Knowles of East Liverpool, Ohio, delivered three dozen bone china plates to the White House in November 1898, the first entirely American-made china acquired for the executive mansion. The design included the Great Seal of the United States in the center with gold tracery on a wide border of cobalt blue (cats. 154, 155). According to Colonel John N. Taylor, president of the company and a political ally of McKinley's, the plates were criticized "severely and seemed to give such poor satisfaction that I have felt it would be wrong to ask pay for them."[37]

The McKinleys continued the Clevelands' practice of purchasing a variety of china patterns from various retailers in Washington. One such open-stock pattern associated with the McKinley administration was made by Haviland and Company and features a wreath of full-blown

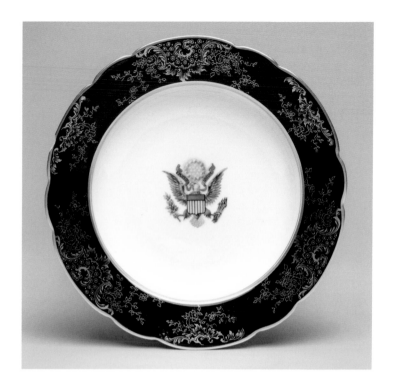

pink roses inside a dark blue narrow rim band. An additional rose drops from the wreath across an inner gold border that encloses a gold filigree medallion. Pieces of this china at the White House also display the Dulin and Martin mark; perhaps the pattern was designed specifically for the Washington retailer. The platter, plate, and cup and saucer included here bear both the Haviland and the Dulin and Martin marks but do not have a verifiable history of use in the White House (cats. 156–58).

CATS. 154, 155. *Two Plates*, 1898*

American, made by Knowles, Taylor and Knowles Company, East Liverpool, Ohio (1870–1929); porcelain with printed, enamel, and gilt decoration; diameter 7¹¹⁄₁₆ inches (19.6 cm)
MARKS: [printed in green] *EAST LIVERPOOL, O. / K.T. & K. / CHINA* [in a circle made of a belt with buckle]; [United States flag painted in red, white, blue, and gold appears above mark on both]; [illegible incised mark with underscore on cat. 155]
PROVENANCE: McKinley family; sold at Sotheby's, New York, January 17, 2002, lot 137
2006-3-192, 193

CAT. 156. *Platter*, c. 1900*

French, made by Haviland and Company, Limoges (1842–present); imported by Dulin and Martin Company, Washington, D.C. (1899–c. 1920); porcelain with printed, enamel, and gilt decoration; length 17½ inches (44.5 cm)
MARKS: [printed in green] *Haviland / France /* [printed in red] *Haviland & Cº. / Limoges / FOR / DULIN & MARTIN Cº. /* [scroll decoration] */ WASHINGTON, D.C.*; [incised] *16 /* [illegible mark]
PROVENANCE: Mrs. Thomas DeWitt Talmadge; Stanley S. Wohl (1895–1978), Annapolis, Maryland; acquired 1967
2006-3-197

CAT. 157. *Plate*, c. 1900

French, made by Haviland and Company, Limoges (1842–present); imported by Dulin and Martin Company, Washington, D.C. (1899–c. 1920); porcelain with printed, enamel, and gilt decoration; diameter 8½ inches (21.6 cm)
MARKS: [printed in green] *Haviland / France /* [printed in red] *Haviland & Cº. / Limoges / FOR / DULIN & MARTIN Cº. /* [scroll decoration] */ WASHINGTON, D.C.*; [incised illegible mark with underscore]
PROVENANCE: Mrs. Thomas DeWitt Talmadge; Stanley S. Wohl (1895–1978), Annapolis, Maryland; acquired 1967
2006-3-194

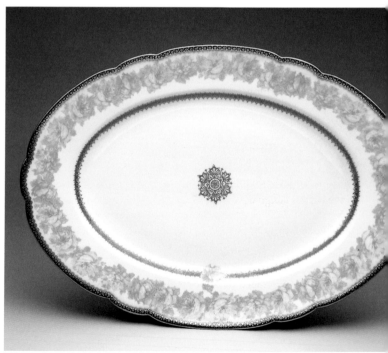

CAT. 158. *After-Dinner Coffee Cup and Saucer,* c. 1900

French, made by Haviland and Company, Limoges (1842–present); imported by Dulin and Martin Company, Washington, D.C. (1899–c. 1920); porcelain with printed, enamel, and gilt decoration; height of cup 2³⁄₁₆ inches (5.6 cm), diameter of saucer 4⁵⁄₁₆ inches (11 cm)

MARKS: [printed in green] *Haviland / France /* [printed in red] *Haviland & Cᵒ. / Limoges / FOR / DULIN & MARTIN Cᵒ. /* [scroll decoration] */WASHINGTON, D.C.*

PROVENANCE: Mrs. Thomas DeWitt Talmadge; Stanley S. Wohl (1895–1978), Annapolis, Maryland; acquired 1967

2006-3-195, 196

THEODORE ROOSEVELT (1858–1919)
President, 1901–9

State Dinner, Dessert, and Breakfast Service, 1903

English, made by Wedgwood factory, Etruria (1759–present); imported by the Van Heusen Charles Company, Albany, New York; porcelain with printed, enamel, and gilt decoration

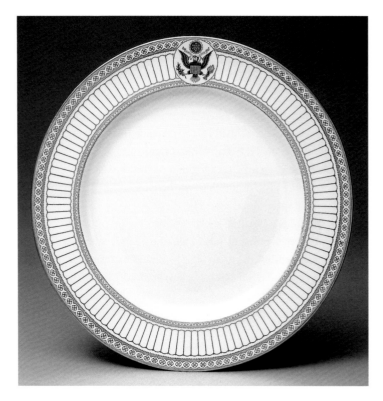

CAT. 159

Edith Kermit Carow Roosevelt (1861–1948) ordered a new state service for 120 to harmonize with the renovation and redecoration of the White House by McKim, Mead and White in 1902. She chose a Wedgwood pattern, then called "Ulanda," from among several English and Continental porcelain samples submitted by the Van Heusen Charles Company of Albany, New York.[38] Wedgwood customized the decoration by adding the Great Seal of the United States in a circular reserve on the border design of simple, radiating gold lines.

CAT. 159. *Dinner Plate**

Diameter 10¼ inches (26 cm)
MARKS: [printed in brown] [Portland Vase symbol] / [line with three stars] / *WEDGWOOD /* [line] */MADE IN ENGLAND /* [impressed] *OH*
PROVENANCE: Butterfield and Butterfield, San Francisco, November 5, 1986, lot 1035
2006-3-200

CAT. 160. *Bread and Butter Plate*

Diameter 5¹³⁄₁₆ inches (14.8 cm)
MARKS: [printed in brown] [Portland Vase symbol] / [line with three stars] / *WEDGWOOD /* [star] */ENGLAND / FROM / THE VAN HEUSEN CHARLES Cᵒ. / ALBANY, N.Y. / Rᵈ Nᵒ 399026 / PATENT APPLIED FOR*
PROVENANCE: Mrs. Eleanore McAllister; sold at Sotheby Parke Bernet, New York, November 19, 1980, lot 443
2006-3-199

CAT. 161. *Saucer*

Diameter 6½ inches (16.5 cm)
MARKS: [printed in brown] *FROM / THE VAN HEUSEN CHARLES Cᵒ. / ALBANY, N.Y. /* [Portland Vase symbol] / [line with three stars] / *WEDGWOOD /* [star] / *ENGLAND / Rᵈ Nᵒ 399026 / PATENT APPLIED FOR*
PROVENANCE: Stanley S. Wohl (1895–1978), Annapolis, Maryland; acquired 1972
PUBLISHED: Detweiler 1975, p. 71, no. 85
2006-3-198

WILLIAM HOWARD TAFT (1857–1930)
President, 1909–13

Chocolate cups and saucers, manufactured by at least two firms in Limoges and decorated at an independent studio, were acquired after the Tafts returned to private life in 1913. Dr. Helen Taft Manning, daughter of President and Mrs. Taft and White House hostess during her mother's recovery from a stroke, recalled that her mother had purchased the cups in Europe.[39] The decoration on the cups consists of simple gold lines and floral sprigs (cats. 162, 163).

Mrs. Manning presented to the White House examples of three other services owned by the Tafts. One of the services, transfer-printed with an eighteenth-century Asiatic pheasant pattern, was made by G. L. Ashworth and Brothers of Hanley, Staffordshire, trading as "Mason's Patent Ironstone," about 1895. Inasmuch as this pattern was widely available, a Taft association for the plate in the McNeil Collection is uncertain (cat. 164).

CATS. 162, 163. *Two Chocolate Cups and Saucers*, c. 1890–95*

French, cups possibly made by G. Demartine and Company, Limoges (c. 1890), or Gustave Demartial, Limoges (c. 1883–1893), and saucers made by an unidentified factory; porcelain with gilt decoration; height of cups 3 inches (7.6 cm), diameter of saucers 4¾ inches (12.1 cm)
MARKS: [printed in green on both cups] *G. D. & C*[IE] / *AVENIR* [in circle with scrolls] / *LIMOGES* / *FRANCE*; [printed in green on both saucers] *COMTE D'ARTOIS* / [crown] / *LIMOGES · FRANCE*
PROVENANCE: Dr. Helen Taft Manning; acquired 1975
PUBLISHED: Detweiler 1975, p. 72, no. 88a, b
2006-3-203–206

CAT. 164. *Plate*, 1895–1905

English, made by George L. Ashworth & Bros., Ltd., Hanley, Staffordshire (1862–1968); earthenware with printed, enamel, and gilt decoration; diameter 10½ inches (26.7 cm)
MARKS: [printed in underglaze brown] *MASON'S* / [crown] / *PATENT IRONSTONE* / *CHINA* [in rectangular cartouche] / *ENGLAND* / [painted in red] *B* / *9686* / [impressed] *S*
PROVENANCE: Eleanor Stiefel; Frank Klapthor, Washington, D.C.; acquired 1973
PUBLISHED: Detweiler 1975, p. 73, no. 87
2006-3-256

WOODROW WILSON (1856–1924)
President, 1913–21

State Dinner and Dessert Service, 1918

American; designed by Frank G. Holmes (American, 1878–1954); made by Lenox Incorporated, Trenton, New Jersey (1899–present); ordered from Dulin and Martin Company, Washington, D.C. (1899–c. 1920); porcelain with enamel and gilt decoration

President and Mrs. Wilson, with the White House Commission of Fine Arts, approved the purchase of the first American-made porcelain state service for the White House from Dulin and Martin Company of Washington, D.C. Made by Lenox China of Trenton, New Jersey, the design was the first for a state service to feature the presidential seal (created by President Hayes in 1877) in raised gold.[40] The Wilson pattern was reordered during the Harding, Coolidge, Hoover, and Clinton administrations.

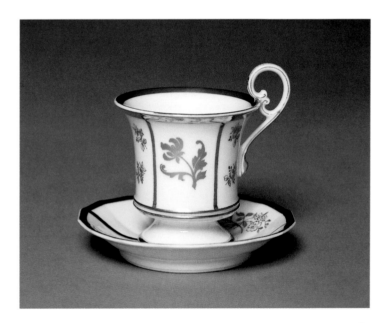

CAT. 162

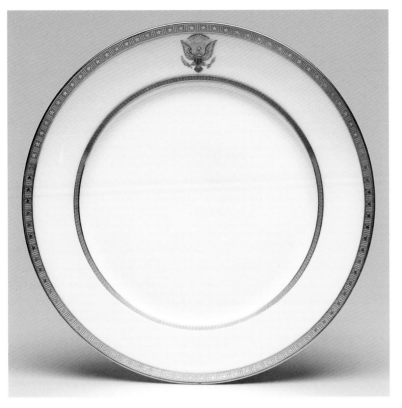

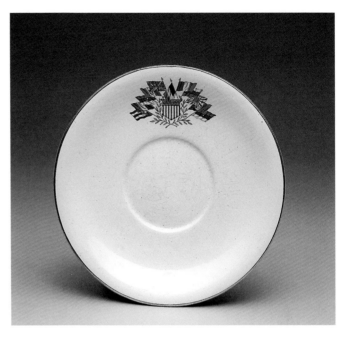

CAT. 165. *Dinner Plate*, 1918*

Diameter 9¾ inches (24.8 cm)

MARKS: [painted in gold] *L* [enclosed in a laurel wreath] / *LENOX* / *DULIN &* *MARTIN Cº.* / *WASHINGTON, D.C.*

LABELS: [printed on a foil label] *LENOX* / *MADE IN* / *U.S.A.* [enclosed in a laurel wreath]; [handwritten on a paper label] *Woodrow Wilson / used by Harding, Coolidge & / Hoover—*

PROVENANCE: Lenox China; Dorothy S. Waterhouse (1894–1982), Boston; acquired 1976

2006-3-208

"Liberty China," c. 1918

President and Mrs. Wilson are listed among those subscribing to a limited edition of tea and dessert services manufactured by Wedgwood during World War I to raise funds for war relief. The "Liberty China," with its arrangement of Allied flags, was designed by Mrs. Robert Cole-

man Taylor, who worked with William H. Plummer and Company of New York.[41]

CAT. 166. *Saucer*, c. 1918*

English; designed by Lillian Gary (Mrs. Robert Coleman) Taylor (American, 1865–1961); made by the Wedgwood factory, Etruria (1759–present); cream-colored earthenware with printed and gilt decoration; diameter 5¹³⁄₁₆ inches (14.7 cm)

MARKS: [impressed underglaze] *ETRURIA* / *ENGLAND*; *WEDGWOOD*; *N / 3__ /* [painted in black] *44984 / 4*

PROVENANCE: Stanley S. Wohl (1895–1978), Annapolis, Maryland; acquired 1967

2006-3-207

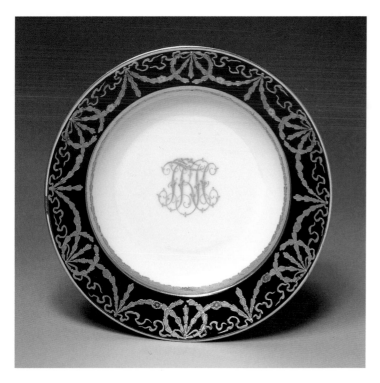

CAT. 167

FRANKLIN DELANO ROOSEVELT (1882–1945)
President, 1933–45

State Dinner Service, 1934
American, made by Lenox Incorporated, Trenton, New Jersey
(1889–present); ordered from William H. Plummer and Company,
New York; porcelain with printed, enamel, and gilt decoration
MARKS: [printed in gold] *THE WHITE HOUSE / 1934 / L* [enclosed in
a laurel wreath] / *LENOX / MADE IN U.S.A. / WM. H. PLUMMER & CO. /
LTD / NEW YORK CITY*

A new state dining service of 1,722 pieces was ordered for the White
House by retailer William H. Plummer of New York from Lenox China
of Trenton, New Jersey, in 1934. At the suggestion of Eleanor Roosevelt,
the inner gold border featured feathers alternating with bands of roses,
motifs taken from the Roosevelt coat of arms. The outer band of dark
blue edged in gold is overlaid with gold stars for the forty-eight states,
and the Seal of the President in enamel colors appears on each piece of
the service (cats. 168–73).

Lenox also made a dining service decorated with gold and cobalt
bands with a polychrome presidential seal on the ledge, for President
Roosevelt's yacht, the *Williamsburg* (cat. 174).

CAT. 168. *Oyster Plate**
Diameter 9⅛ inches (23.2 cm)
PROVENANCE: Raleigh Amyx; acquired 1983
2006-3-218

CAT. 169. *Cocktail Cup*
Height 1¹³⁄₁₆ inches (4.6 cm), diameter 2⅞ inches (7.3 cm)
ADDITIONAL MARK: [impressed] *1507*
PROVENANCE: Set C. Momjian, Philadelphia; acquired 1990
2006-3-220

CAT 170. *Bouillon Cup and Saucer*
Height of cup 2¼ inches (5.7 cm), diameter of saucer 5⅝ inches (14.3 cm)
ADDITIONAL MARK: [impressed on cup] *1305*
PROVENANCE: Set C. Momjian, Philadelphia; acquired 1996
2006-3-222, 223

WARREN G. HARDING (1865–1923)
President, 1921–23

The White House china collection includes two patterns chosen by
Florence Kling Harding (1860–1924) for family use. Examples are also
preserved at the Harding home in Marion, Ohio. The Dresden service,
with Mazarine-blue and gold tracery borders, is embellished with the
initials "FKH."

CAT. 167. *Soup Plate*, c. 1891–1914*
German, decorated by Richard Klemm Decorating Studio, Dresden (1869–
1949); porcelain with enamel and gilt decoration; diameter 9¼ inches (23.5 cm)
MARKS: [stamped in blue] [crown] / *RK* [addorsed] / *Dresden / GERMANY*;
[gold dot]; [impressed]*24 / N /* [crown-topped coat of arms with illegible
letters]
PROVENANCE: Set C. Momjian, Philadelphia; acquired 1984
2006-3-209

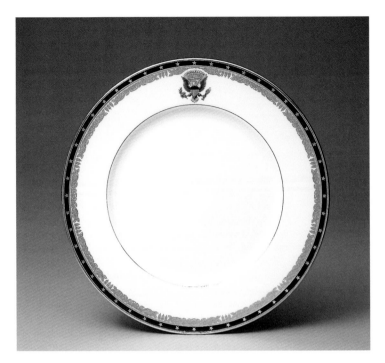

CAT. 168

CAT. 174

CAT. 171. *Dinner Plate*

Diameter 10⅝ inches (27 cm)

MARKS: [printed in gold] *L* [enclosed in a laurel wreath] / *LENOX* / *MADE IN U.S.A.*

LABELS: [typewritten] *D.S. / Waterhouse / 80935 /* [handwritten] *20;* [handwritten] *Franklin Delano Roosevelt / Tudor Rose & feather used from / his coat-of-arms. / (Lenox)*

PROVENANCE: Lenox China; Dorothy S. Waterhouse (1894–1982), Boston; acquired 1976

2006-3-215

CAT. 172. *Entree or Fish Plate*

Diameter 7⅜ inches (18.7 cm)

PROVENANCE: Set C. Momjian, Philadelphia; acquired 1996

2006-3-221

CAT. 173. *After-Dinner Coffee Cup and Saucer*

Height of cup 2¼ inches (5.7 cm), diameter of saucer 4¾ inches (12.1 cm)

PROVENANCE: Set C. Momjian, Philadelphia; acquired 1996

2006-3-226, 227

CAT. 174. *Plate, 1934**

Porcelain with printed, enamel, and gilt decoration; diameter 10⁹⁄₁₆ inches (26.8 cm)

MARKS: [printed in gold] *L* [enclosed in a laurel wreath] / *LENOX* / *MADE IN U.S.A.* [painted in gold] *1830 / T405B*

PROVENANCE: Set C. Momjian, Philadelphia; acquired 1984

2006-3-219

English and German Tableware

A mixed service of at least four patterns of porcelain with simple border lines of blue and gold was assembled by President Roosevelt's mother for use at the Roosevelt residence in Hyde Park, New York. President and Mrs. Roosevelt continued to use the china, and pieces were auctioned in the Hammer Galleries sale for the Estate of Eleanor Roosevelt in the fall of 1964. Two plates from the auction bear the impressed mark "F & M," which was used by the Bohemian firm of Fischer and Mieg in the second half of the nineteenth century (cat. 175).

Eleanor Roosevelt (or her mother-in-law) may have had a collection of cups and saucers. Cups and saucers in several patterns were sold at the estate auction in 1964 (cats. 176–78).

CAT. 175. *Plate*, c. 1875

Bohemian, made by Fischer and Mieg, Pirkenhammer (1857–1918); porcelain with enamel and gilt decoration; diameter 8½ inches (21.6 cm)

MARKS: [impressed] *F & M / 8*

LABEL: [printed] *ESTATE OF / ELEANOR / ROOSEVELT / NO.* [handwritten] *2288* / [printed] *HYDE PARK, N.Y.*

PROVENANCE: Estate of Eleanor Roosevelt, Hammer Galleries, New York, 1964; Stanley S. Wohl (1895–1978), Annapolis, Maryland; acquired 1967

2006-3-210

CAT. 176. *Cup and Saucer*, c. 1910

English, made in Staffordshire; imported by Gilman Collamore Company, New York; porcelain with printed, enamel, and gilt decoration; height of cup 2 inches (5.1 cm), diameter of saucer 4⅝ inches (11.7 cm)

MARKS: [printed in green] *CROWN* / [crown above interlaced scrolls] / *STAFFORDSHIRE / ENGLAND.* / [printed in red] *GILMAN / COLLAMORE Cº / NEW YORK*; [painted in red] *A5337 / 7*

LABEL: [printed] *ESTATE OF / ELEANOR / ROOSEVELT / NO.* [handwritten] *101 / 2 c/s* / [printed] *HYDE PARK, NY* [on saucer]

PROVENANCE: Estate of Eleanor Roosevelt, Hammer Galleries, New York, 1964; Stanley S. Wohl (1895–1978), Annapolis, Maryland; acquired 1967

PUBLISHED: Detweiler 1975, p. 82, no. 97a, b

2006-3-211, 212

CAT. 177. *Cup and Saucer*, c. 1880

Probably English; porcelain with enamel and gilt decoration; height of cup 2¼ inches (5.7 cm), diameter of saucer 4¾ inches (12.1 cm)

MARKS: [incised zigzag on cup]

LABEL: [printed] *ESTATE OF / ELEANOR / ROOSEVELT / NO.* [handwritten] *41* / [printed] *HYDE PARK, N.Y.* [on saucer]

PROVENANCE: Estate of Eleanor Roosevelt, Hammer Galleries, New York, 1964; Stanley S. Wohl (1895–1978), Annapolis, Maryland; acquired 1972

2006-3-213, 214

CAT. 178. *Cup and Saucer*, c. 1825*

Probably English; earthenware with underglaze printed and enamel decoration; height of cup 2³⁄₁₆ inches (5.6 cm), diameter of saucer 5⅝ inches (14.3 cm)

MARKS: [painted in green] *O* [on cup]; *A* [on saucer]

LABELS: [handwritten] *Great-great grandmother / of F.D.R.*; [handwritten] *Great-great grandmother of Franklin / Delano Roosevelt (named Delano). She / lived in summer in Wiscasset, Me. The cup / was eventually given to Mrs. Robt Dallas / 6 Huse St. Metheun, Mass by a Delano / relative. She gave it to D.S.W* [on saucer]

PROVENANCE: Delano family; Mrs. Robert Dallas; Dorothy S. Waterhouse (1894–1982), Boston; acquired 1976

2006-3-216, 217

CAT. 178

HARRY S. TRUMAN (1884–1972)
President, 1945–53

State Dinner Service, 1951

American, made by Lenox Incorporated, Trenton, New Jersey (1889–present); ordered from B. Altman and Company, New York (1865–1989); porcelain with enamel and gilt decoration

MARKS: [printed in gold] *L* [enclosed in a laurel wreath] / *WHITE HOUSE SERVICE / BY LENOX / MADE IN U.S.A. / B. ALTMAN & CO.*

In 1951, a new state dining service to complement the redecorated state dining room at the White House was ordered by B. Altman and Company from Lenox China in Trenton, New Jersey. The principal design elements of the Truman china are a band of soft green between a plain gold line on the outer rim and a gold band etched with a cable or chain motif (cat. 179). The presidential seal is rendered in gold on the border of each piece and in the center of the service plates, which have a wider

CAT. 179

band of green and a heavier outer rim of gold. By executive order in 1945, President Truman standardized the design of the presidential seal so that the eagle faces the olive branch of peace rather than the bundle of arrows as seen on the Wilson and Roosevelt state services.

President Truman also used the presidential yacht *Williamsburg*, but a new service was produced for the yacht by Lenox China. Thirteen prominent gold stars on a wide cream band are bordered by dark blue and gold bands. The presidential seal is applied to the center of the well (cat. 183).

CAT. 179. *Service Plate**
Diameter 11⅜ inches (28.9 cm)
ADDITIONAL MARKS: [printed in gold] *X-307*
PROVENANCE: Set C. Momjian, Philadelphia; acquired 1984
2006-3-232

CAT. 180. *Dinner Plate*
Diameter 10⅝ inches (27 cm)
ADDITIONAL MARKS: [printed in gold] *X-308*
LABEL: [printed in white letters on a green background] *L* [enclosed in a laurel wreath] / *Command performances / in fine china—by Lenox /* [typewritten] *White House / Service / President / Harry S. Truman*; [handwritten] *Harry Truman – Used later / by Eisenhower, Kennedy & / Johnson*
PROVENANCE: Lenox China; Dorothy S. Waterhouse (1894–1982), Boston; acquired 1976
2006-3-231

CAT. 181. *Entrée Plate*
Diameter 9³⁄₁₆ inches (23.4 cm)
ADDITIONAL MARKS: [printed in gold] *X-308*
LABEL: [handwritten] *Harry Truman—Used also by / Eisenhower / Kennedy & / Johnson*
PROVENANCE: Lenox China; Dorothy S. Waterhouse (1894–1982), Boston; acquired 1976
2006-3-230

CAT. 182. *Teacup and Saucer*
Height of cup 2 inches (5.1 cm), diameter of saucer 6 inches (15.2 cm)
ADDITIONAL MARKS: [printed in gold] *X-308*
LABELS: [handwritten] *Harry Truman* [on cup]; *Harry Truman – Lenox* [on saucer]; [typewritten] *D.S. / Waterhouse / 80935 /* [handwritten] *52* [inside cup]
PROVENANCE: Lenox China; Dorothy S. Waterhouse (1894–1982), Boston; acquired 1976
2006-3-228, 229

CAT. 183

CAT. 183. *Plate*, c. 1950*
Porcelain with printed, enamel, and gilt decoration; diameter 10⅝ inches (27 cm)
MARKS: [printed in gold] *L* [enclosed in a laurel wreath] / *LENOX / MADE IN U.S.A.*; [painted in gold] *1830 / x-309*
PROVENANCE: Set C. Momjian, Philadelphia; acquired 1984
2006-3-233

English Porcelain

President Truman's airplane, the *Independence*, was furnished with a dining service made by the English firm Royal Doulton Bone China. The pattern, "The Beverley," consists of pink floral motifs and blue ribbons on a scalloped ledge (cat. 184).

CAT. 184. *Plate*, c. 1950*
English, made by Doulton and Company, Lambeth (1815–present); "The Beverley" pattern; porcelain with printed and gilt decoration; diameter 10¾ inches (27.3 cm)
MARKS: [printed in green] [crowned lion on top of a crown above a circle] *MADE IN / ENGLAND / ROYAL · DOULTON /* [interlaced lines] /

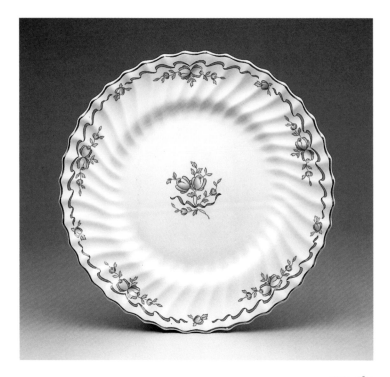

ENGLAND / BONE CHINA / [printed in brown] THE BEVERLEY / [painted in black] H4797 / H
PROVENANCE: Set C. Momjian, Philadelphia; acquired 1990
2006-3-234

DWIGHT DAVID EISENHOWER
(1890–1969)
President, 1953–61

In 1955, during President Eisenhower's first term, Mamie Doud Eisenhower (1896–1979) selected a design for 120 service plates, which were ordered directly from Castleton China, a subsidiary of Shenango China of New Castle, Pennsylvania, to be used with the Truman state service. The plates have wide coin-gold borders of medallions and the presidential seal in gold at the center. They are marked "Castleton Studios" on the reverse to indicate the factory's line of made-to-order handcrafted products (cat. 185).

Shenango China, the parent company of Castleton, made a dining service for President Eisenhower's airplane, *Columbine*. Decorated with blue and white columbine flowers, the pieces also bear the president's initials, "DDE" (cat. 186).

Castleton China made a special edition of plates to commemorate President Eisenhower's birthday. Decorated with motifs recalling his Pennsylvania German heritage, the plates were sold to collectors (cat. 187).

During President Eisenhower's visit to Maine in June 1955, the Third Congressional District presented to him a set of locally made earthenware dishes for Mrs. Eisenhower's use at their Gettysburg farm. Made by Rowantrees Pottery of Blue Hill, Maine, the informal tableware is glazed in shades ranging from light gray to mirror black (cat. 188).

CAT. 185. *State Service Plate*, 1955*
American, made by Castleton China, subsidiary of Shenango Pottery Company, New Castle, Pennsylvania (active 1939–1976); porcelain with gilt decoration; diameter 11⅝ inches (29.5 cm)
MARKS: [printed in black and gold] CASTLETON / [lyre] / [ribbon beneath] MADE IN U.S.A. / STUDIOS / [painted in gold] THE WHITE HOUSE / NOVEMBER 1955
PROVENANCE: Set C. Momjian, Philadelphia; acquired 1995
2006-3-238

CAT. 186. *Plate*, 1956*
American, made by Shenango Pottery Company, New Castle, Pennsylvania (active 1939–1976); porcelain with printed and gilt decoration; diameter 10 1/16 inches (25.5 cm)
MARKS: [printed in gold] THE PRESIDENTIAL PLANE / COLUMBINE / WASHINGTON, D.C. / MAY 1956 / SHENANGO CHINA / [illegible mark] / [painted in black] 45
PROVENANCE: Set C. Momjian, Philadelphia; acquired 1990
2006-3-237

CAT. 187. *Plate*, c. 1950
American, made by Castleton China, subsidiary of Shenango Pottery Company, New Castle, Pennsylvania (active 1939–1976); porcelain with printed, enamel, and gilt decoration; diameter 10⅞ inches (27.6 cm)
MARKS: [printed in black] A LIMITED EDITION / [intertwined doves above a two-tiered birthday cake with candles, swags, and flowers] / This plate commemorates / President Eisenhower's first / birthday in the White House / The Pennsylvania Dutch / symbol of the intertwined / doves signifies Love and / Peace for which

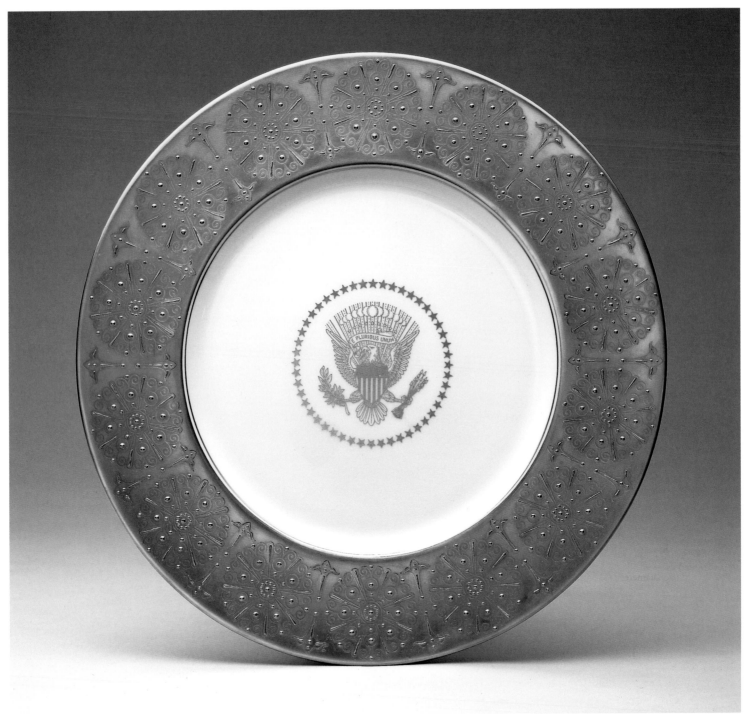

CAT. 185

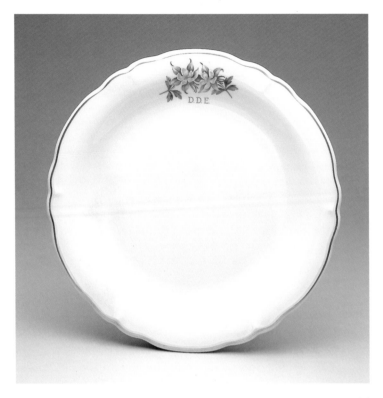

our Presi- / dent firmly stands. / MADE EXPRESSLY / FOR THIS OCCASION BY / CASTLETON CHINA / NEW CASTLE, PENNSYLVANIA / [lyre] / [stamped in gold] © / 49 / [stamped in black] V
PROVENANCE: Stanley S. Wohl (1895–1978), Annapolis, Maryland; acquired 1967
2006-3-235

CAT. 188. *Plate, 1955**
American, made by Rowantrees Pottery, Blue Hill, Maine; red earthenware with gray-black glaze; diameter 7 ¹³⁄₁₆ inches (19.8 cm)
LABELS: [printed in blue] *ROWANTREES POTTERY / BLUE HILL, MAINE;* [handwritten] *Dwight Eisenhower— / Breakfast set for Gettysburg farm / presented by Rowantrees Pottery;* [printed in blue] *Dorothy S. Waterhouse / 169 Commonwealth Avenue / Boston, Massachusetts*
PROVENANCE: Dorothy S. Waterhouse (1894–1982), Boston; acquired 1976
2006-3-236

JOHN FITZGERALD KENNEDY
(1917–1963)
President, 1961–63

Senator and Mrs. John F. Kennedy used an antique service of Wedgwood creamware, decorated with a simple bright-green band and line border, at their home in Georgetown (cat. 191). Individual pieces of the service, made about 1820 in Staffordshire, England, are impressed "Wedgwood" and bear various impressed potters' marks. Surviving pieces from the service were auctioned in thirteen lots at the sale of the Jacqueline Kennedy Onassis Estate at Sotheby's in 1996.

CAT. 191

LYNDON BAINES JOHNSON
(1908–1973)
President, 1963–69

State Dinner Service, 1968

American; designed by Van Day Truex (American, 1904–1979) with André Piette (American, b. Belgium; 1934–1984) and Claudia Taylor "Lady Bird" Johnson (1912–2007); made by Castleton China, subsidiary of Shenango Pottery Company, New Castle, Pennsylvania (active 1939–1976); ordered from Tiffany and Company, New York (1837–present); porcelain with printed, enamel, and gilt decoration
MARKS: [printed in gold] *THE WHITE HOUSE / 1968 / DESIGNED BY TIFFANY AND COMPANY / MADE BY CASTLETON CHINA, INC. / U.S.A.* ©

The state dining service ordered for the White House in 1967 was designed under the close direction of Claudia Taylor "Lady Bird" Johnson. A departure from the formal patterns favored by earlier twentieth-century presidents, the design is based partly on history, with a return to the Monroe interpretation of the Great Seal, and partly on Mrs. Johnson's enthusiasm for the conservation movement. Most pieces were decorated with one or more wildflowers with a background or border of gold dots; the after-dinner coffee cup features the Texas bluebonnet. Designed by Van Day Truex of Tiffany and Company, the service was manufactured in New Castle, Pennsylvania, by Castleton China, a subsidiary of Shenango Pottery that was formed in 1940 to create fine china in addition to the durable restaurant ware that was the mainstay of Shenango production. During the manufacture of the Johnson state service, Shenango was absorbed into the Interpace Corporation of New Castle. Neither Castleton nor Shenango is in operation today.

CATS. 189–91. *Three Plates*, c. 1820*

English, made by Wedgwood factory, Etruria (1759–present); cream-colored earthenware with enamel decoration; diameter 10 inches (25.4 cm)
MARKS: [impressed] *WEDGWOOD / M /* [asterisk] / [three dots in a pyramid painted in green] on cat. 189; [impressed] *WEDGWOOD / M / 5* on cat. 190; [impressed] *WEDGWOOD / M / 2* on cat. 191
PROVENANCE: Sold at Sotheby's, New York, May 9, 1996, lot 1108
2006-3-239-241

CAT. 192. *Service Plate**

Diameter 11¾ inches (29.8 cm)
ADDITIONAL MARKS: [printed in gold] *CASTLETON CHINA INC. / PRIVATE COLLECTION*
PROVENANCE: Set C. Momjian, Philadelphia; acquired 1984
2006-3-244

CAT. 193. *Dinner Plate*

Diameter 10¾ inches (27.3 cm)
PROVENANCE: Set C. Momjian, Philadelphia; acquired 1984
2006-3-243

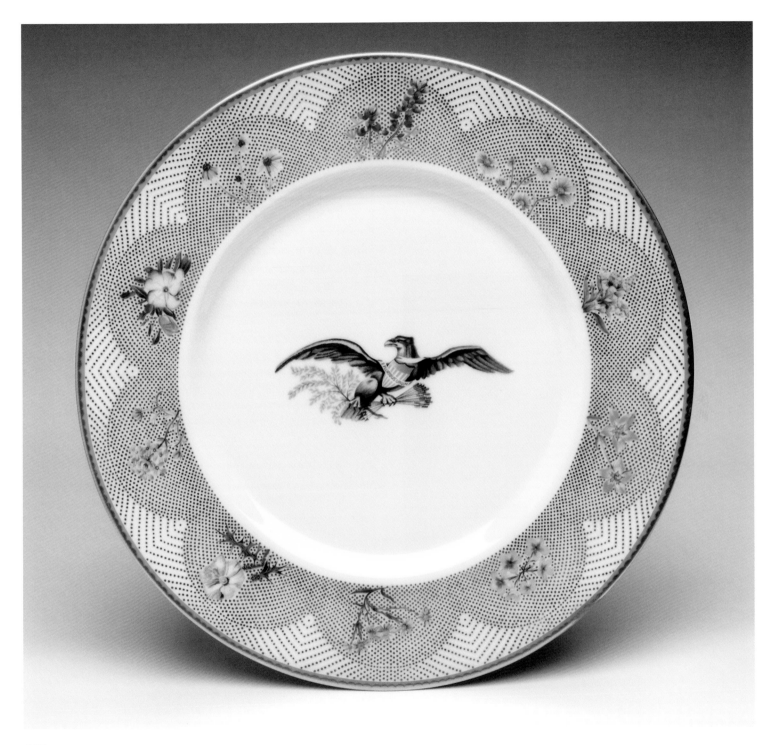

CAT. 192

CAT. 194. *Entree or Fish Plate*

Diameter 8 inches (20.3 cm)
PROVENANCE: Set C. Momjian, Philadelphia; acquired 1982
2006-3-242

CAT. 195. *Cream Soup Cup and Stand*

Height of cup 2 inches (5.1 cm), diameter of stand 7⅛ inches (18.1 cm)
PROVENANCE: Set C. Momjian, Philadelphia; acquired 1990
2006-3-245, 246

CAT. 196. *After-Dinner Coffee Cup and Saucer*

Height of cup 2⅜ inches (6 cm), diameter of saucer 4⅞ inches (12.4 cm)
PROVENANCE: Set C. Momjian, Philadelphia; acquired 1990
2006-3-247, 248

CAT. 199

JIMMY CARTER (b. 1924)
President, 1977–81

In 1986, friends of President and Mrs. Carter presented to them a service from Lenox China decorated with the gold presidential seal and a green border. Set C. Momjian led the fundraising for the project. Although the china is marked in gold "PRESIDENT JIMMY CARTER / 1980," the service was completed after President Carter left the White House in 1981 (cats. 197, 198).

Set C. Momjian collaborated with Woodmere China of New Castle, Pennsylvania, to design a dining service for President Jimmy Carter's fishing lodge in Georgia. The pieces are decorated with fishing flies, rimmed with a green band and line, and display Jimmy Carter's monogram at the center (cat. 199). The pattern, without the monogram, was also available to the public.

CAT. 197. *Service Plate*, 1985

American, made by Lenox Incorporated, Trenton, New Jersey (1889–present); porcelain with enamel and gilt decoration; diameter 10⅝ inches (27 cm)
MARKS: [printed in gold] *PRESIDENT JIMMY CARTER / 1980 / L* [enclosed in a laurel wreath] / © *LENOX* ® / *MADE IN U.S.A.*
PROVENANCE: Set C. Momjian, Philadelphia; acquired 1985
2006-3-249

CAT. 198. *Dinner Plate*, 1985

American, made by Lenox Incorporated, Trenton, New Jersey (1889–present); porcelain with enamel and gilt decoration; diameter 10⁹⁄₁₆ inches (26.8 cm)
MARKS: [printed in gold] *PRESIDENT JIMMY CARTER / 1980 / L* [enclosed in a laurel wreath] / © *LENOX* ® / *MADE IN U.S.A.* / [painted in gold] *24*
PROVENANCE: Set C. Momjian, Philadelphia; acquired 1985
2006-3-250

CAT. 199. *Service Plate*, 1989*

American; designed by Set C. Momjian (American, b. 1930); made by Woodmere China, New Castle, Pennsylvania (c. 1970–present); porcelain with printed and enamel decoration; diameter 12¹⁄₁₆ inches (30.7 cm)
MARKS: [printed in black] *Made Expressly for / President Jimmy Carter's / Walnut Mountain Cabin / Ellijay, Georgia* / © *WOODMERE* ® / [a goblet surrounded by wings] / *CHINA*
PROVENANCE: Set C. Momjian, Philadelphia; acquired 1990
2006-3-251

RONALD REAGAN (1911–2004)
President, 1981–89

In 1981, a red-and-gold bordered state service was given to the White House by the Knapp Foundation through the White House Historical Association. Additional china made for the White House during President Reagan's administration included a dining service for use in the White House "mess," at Camp David, and aboard Air Force One. Manufactured in Japan and England in 1983 by the Dallas-based firm Fitz and Floyd, the porcelain displays the company's "Starburst" design of blue, gold, and red borders with the presidential seal added to each piece (cat. 200).

During the Reagan administration, President and Mrs. Ford sponsored a breakfast for the living First Ladies. Set C. Momjian designed a special plate with red and gold borders and signatures of the First Ladies on the reverse. The plates were made by Lenox in 1984 (cat. 201).

CAT. 200. *Cup and Saucer*, 1983
Japanese; designed by Dale Hodges with Robert C. Floyd; made by Chunichi Toki Company, Nagoya; imported by Fitz and Floyd, Dallas, Texas (1960–present); "Starburst" pattern; porcelain with gilt and "inglaze" blue decoration; height of cup 2⅛ inches (5.4 cm), diameter of saucer 5⅝ inches (14.3 cm)
MARKS: [printed in gold] *White House Service / by Robert C. Floyd / Fitz and Floyd, Inc. / Fine China / 1983* [in script]
PROVENANCE: Set C. Momjian, Philadelphia; acquired 1987
2006-3-252, 253

CAT. 201. *Breakfast Plate*, 1984*
American; designed by Set C. Momjian (American, b. 1930); made by Lenox Incorporated, Trenton, New Jersey (1889–present); porcelain with enamel and gilt decoration; diameter 10⁹⁄₁₆ inches (26.8 cm)
MARKS: [printed in gold] *First Ladies Breakfast / April 20, 1984* [in script] / *L* [enclosed in a laurel wreath] / *LENOX ® / MADE IN USA*; [printed in gold on inner rim] *SPONSORS · PRESIDENT AND MRS. GERALD R. FORD / HOSTS · THE HONORABLE AND MRS. SET CHARLES MOMJIAN*; [signatures printed in brown (clockwise from top)] *Nancy Reagan / Lou Henry Hoover / Eleanor Roosevelt / Bess W. Truman / Mamie Doud Eisenhower / Jacqueline Kennedy / Lady Bird Johnson / Patricia Nixon / Betty Ford / Rosalynn Carter*
PROVENANCE: Set C. Momjian, Philadelphia; acquired 1984
2006-4-258

CAT. 201

NOTES

1. *Catalogue of the Governor Lyon Collection of Oriental and Occidental Ceramics . . .*, April 24, 1876 (New York: Henry D. Miner, Auctioneer, 1876).

2. Margaret Brown Klapthor et al., *Official White House China*, 2d ed. (New York: Harry N. Abrams, 1999), p. 99.

3. Francis W. Dickins, *Catalogue of the Dickins Collection of American Historical China* (Washington, D.C.: privately printed, 1898).

4. "Invoice of goods shipped by Richd Washington to George Washington from London, per the *Sally*," August 20, 1757. Library of Congress, Manuscript Division, George Washington Papers. Cited in Susan Gray Detweiler, *George Washington's Chinaware* (New York: Harry N. Abrams, 1982), p. 200.

5. "Last Will and Testament of Martha Washington," September 22, 1800. Mount Vernon Ladies' Association Archives. See Detweiler, *George Washington's Chinaware*, p. 220.

6. Detweiler, *George Washington's Chinaware*, p. 84.

7. Supplement to the master's declaration of entry for the *Lady Louisa*. Philadelphia, April 25, 1796. National Archives Trust Fund. Cited In Detweiler, *George Washington's Chinaware*, p. 154.

8. Detweiler, *George Washington's Chinaware*, pp. 67–77.

9. Gouverneur Morris (Paris) to George Washington (New York), January 24, 1790. Gouverneur Morris Papers, Library of Congress, Washington, D.C.

10. *Manufacture Nationale de Sèvres, Registre de Vente*, Vy 7, fol. 15, May 9, 1778. Cited in Detweiler, *George Washington's Chinaware*, p. 193.

11. Invoice for the "Save China." Archives of the Mount Vernon Ladies' Association. Cited in Detweiler, *George Washington's Chinaware*, pp. 123, 126.

12. Examples are in the collections of the White House and the Smithsonian National Museum of American History in Washington, D.C.

13. Conover Hunt-Jones, *Dolley and the Great Little Madison* (Washington, D.C.: American Institute of Architects Foundation, 1977), p. 121.

14. Madison Papers, University of Virginia, Alderman Library 2988, Box 21. Cited in Klapthor et al., *Official White House China*, p. 37.

15. Hunt-Jones, *Dolley and the Great Little Madison*, p. 121.

16. Stan F. Henkels, *Catalogue . . . Estate of Dolley P. Madison* (Philadelphia, 1899).

17. Klapthor et al., *Official White House China*, p. 43.

18. Two plates are in the collections of the Peabody Essex Museum, and an oval serving dish is at the American Museum in Britain, Claverton Manor, Bath.

19. Klapthor et al., *Official White House China*, p. 42.

20. *The Opening of the Adams-Clement Collection*, Smithsonian Institution Publication 4055 (Washington, D.C.: Smithsonian Institution, 1951).

21. Klapthor et al., *Official White House China*, p. 53.

22. Ibid., pp. 54–55.

23. Ibid., p. 57.

24. Stephen Girard's bank notes of the 1820s depicted the eagle-on-shield motif. A Lafayette ribbon is in the collections of the Print Department, Library Company of Philadelphia.

25. Jane Shadel Spillman, *White House Glassware* (Washington, D.C.: The White House Historical Association, 1989), p. 34.

26. Klapthor et al., *Official White House China*, p. 69.

27. Inventory taken in 1848. See ibid., p. 73

28. Ibid., p. 294.

29. Ibid., p. 77. The centerpiece was found in the attic of the White House by Mrs. Benjamin Harrison.

30. Susan Gray Detweiler, *American Presidential China*, exh. cat. (Washington, D.C.: Smithsonian Institution, 1975), p. 47.

31. Klapthor et al., *Official White House China*, pp. 90, 99, 125.

32. Ibid., p. 87; Detweiler, *American Presidential China*, pp. 47–49.

33. Klapthor et al., *Official White House China*, p. 95. Lissac's given name is not known.

34. Ibid., p. 93.

35. Haviland and Company, *The White House Porcelain Service: Designs by an American Artist, Illustrating Exclusively American Fauna and Flora. 1879* (New York, 1880). Reproduced in Klapthor, *Official White House China*, pp. 201–88. Theodore R. Davis, whose illustrations appeared regularly in *Harper's Weekly*, was a well-known artist of the Civil War and the West.

36. Klapthor et al., *Official White House China*, p. 290.

37. Ibid., p. 143.

38. Ibid., p. 146.

39. Dr. Helen Taft Manning, conversation with the author, Haverford, Pennsylvania, 1975.

40. Klapthor et al., *Official White House China*, p. 156.

41. Detweiler, *American Presidential China*, p. 76.